PICTURING THE ALASKA-YUKON-PACIFIC EXPOSITION

THE PHOTOGRAPHS OF FRANK H. NOWELL

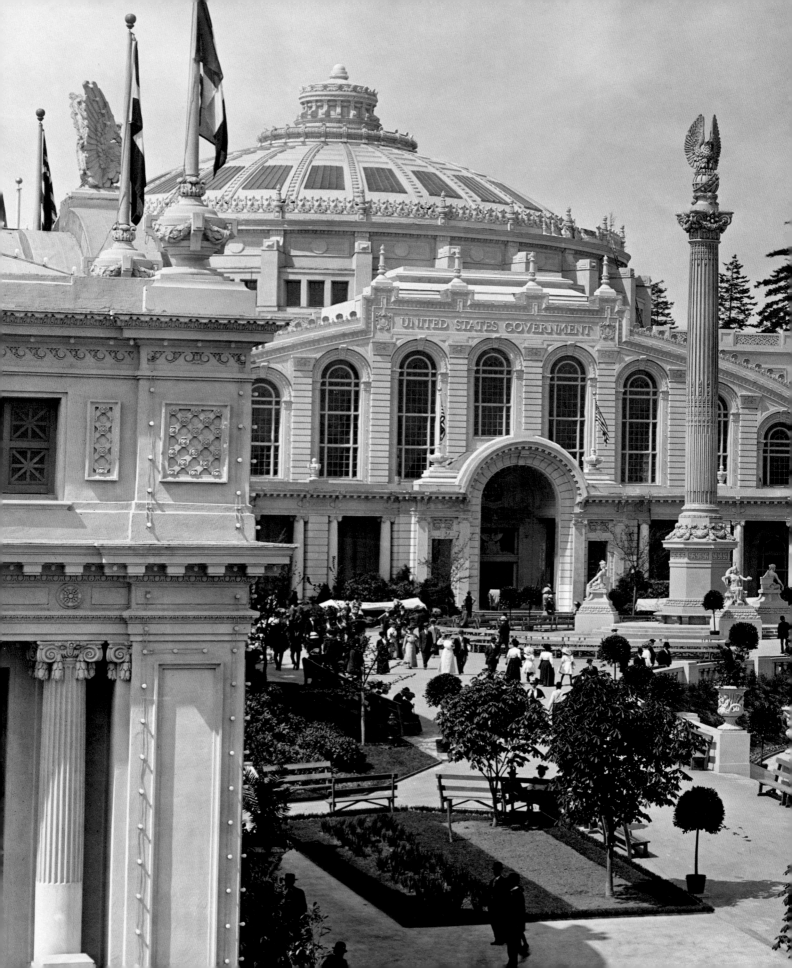

PICTURING THE ALASKA-YUKON-PACIFIC EXPOSITION

THE PHOTOGRAPHS OF FRANK H. NOWELL

Nicolette Bromberg

with the A-Y-P Rephotographic Project
by John Stamets

UNIVERSITY OF WASHINGTON PRESS

SEATTLE AND LONDON

Publication of this book was supported in part by a generous grant from the Office of the Provost, University of Washington.

University of Washington Press, PO Box 50096, Seattle, WA 98145
www.washington.edu/uwpress

Library of Congress Cataloging-in-Publication Data
Bromberg, Nicolette.
Picturing the Alaska-Yukon-Pacific Exposition: the photographs
of Frank H. Nowell / Nicolette Bromberg; with the A-Y-P
Rephotographic Project by John Stamets.—1st ed.
p. cm.
Includes bibliographical references.
ISBN 978-0-295-98929-7
1. Alaska-Yukon-Pacific Exposition (1909: Seattle, Wash.)
2. Exhibition—Washington—Seattle. 3. Seattle (Wash.)—
Pictorial works. I. Nowell, Frank H., 1864–1950.
II. Stamets, John, 1949– III. Title.
T890.C1B76 2009
779′.99074797772—dc22 2009016302

Pages 2–3: Court of Honor, 1909 (plate 12)
Endsheets: Alaska-Yukon-Pacific Exposition admission tickets,
May 1909 (plate 17)

Designed by John Hubbard
Edited by Julidta C. Tarver
Proofread by Pat Scott
Typeset by Maggie Lee
Color management by iocolor, Seattle
Produced by Marquand Books, Inc., Seattle
www.marquand.com
Printed in China by C&C Offset Printing Co., Ltd.

CONTENTS

FOREWORD

It is astounding to think about our picturesque University of Washington campus and how different it might look today were it not for the 1909 Alaska-Yukon-Pacific Exposition (A-Y-P), Seattle's first world's fair.

In 1900 and 1904, after the university moved from downtown Seattle to its current location, various plans were proposed for expanding the new campus beyond its few scattered buildings. Historians theorize that the designers who were consulted (including the Olmsted Brothers) must have visited campus on cloudy days because there is no mention of its most significant feature—the looming view of fourteen-thousand-foot Mount Rainier.

Fortunately, the Olmsteds returned for a fresh look a few years later, when they were selected to design the grand fair that would be temporarily constructed on raw university land at the end of the streetcar line. Even more fortunately, a gifted photographer, Frank H. Nowell, was there to capture every step of the process.

In this comprehensive and stunningly illustrated book, *Picturing the Alaska-Yukon-Pacific Exposition: The Photographs of Frank H. Nowell,* Nicolette Bromberg takes the reader back to 1909 Seattle, when brightly lit buildings were a novelty, the city was still seen by many as a raw gold rush town, and the peoples and cultures of the Pacific Rim, including Alaska and the Yukon Territory, were exotic unknowns.

Using carefully selected photographs from the University of Washington Libraries Special Collections archives, as well as "rephotographs" by John Stamets and his students that show many of these same sites today, Bromberg reveals how, seemingly overnight, acres of untamed forest were transformed into a wonderland of illuminated streets and walkways, dramatic water displays, and ornate Beaux Arts buildings. Because Beaux Arts architecture is typically oriented to some defining feature, majestic Mount Rainier became the focal point for the fair—and has remained that for the modern-day campus, whose core design follows the contours of the A-Y-P.

Today, only two buildings from the A-Y-P remain in more or less intact form—the Fine Arts Building, now Architecture Hall, and the Women's Building, now Cunningham Hall Women's Center. However, what are now called Rainier Vista and Drumheller Fountain continue to endure as the most-photographed sites on campus, a tribute to both the planners of the A-Y-P and the photographer who recorded this magical event for the enjoyment of generations to come.

Nicolette Bromberg, visual materials curator for the University of Washington Libraries, is responsible for the Libraries' historical visual materials. John Stamets has been documenting changes to historic buildings and structures on the university's Seattle campus since 1987 and has been a lecturer in photography in the School of Architecture since 1992.

Mark Emmert
President, University of Washington

ACKNOWLEDGMENTS

Thanks are due to many people who helped make this book possible, starting with those who helped create the largest existing collection of original Frank H. Nowell Alaska-Yukon-Pacific Exposition photographs. We are fortunate that Professor Edmond Meany, historian Clarence Bagley, Mrs. J. E. Chilberg (widow of the president of the A-Y-P), and others who personally experienced the 1909 exposition had the foresight to save and pass on their original Nowell photographs to the University of Washington Libraries and that the unsung early library staff knew it was important to retain them for future generations. I also wish to thank the staff at the University of Washington Libraries, especially Carla Rickerson, head of Public Services, for her support for this project and for sharing her personal collection of A-Y-P research materials. A big thanks also goes to Phyllis Wise, provost and executive vice-president, for recognizing the value of funding campus-wide A-Y-P projects to celebrate the upcoming centennial and to Theresa Doherty, assistant vice-president for Regional Affairs, for her support of this particular project. Thanks are also due to other A-Y-P researchers out there who gave advice and leads, especially Erik Smith for sharing his great newspaper finds and Paula Becker of HistoryLink and Kathleen Dannenhold of the university's Office of Regional Affairs for their detailed suggestions for improving the manuscript. I would like to make a special acknowledgment to my colleague Joyce Agee, Libraries associate director of Advancement, for her belief in the importance of the project and her persistence in helping to make it a reality. And lastly, thanks to Anna Lee Frohlich, who shared her research on the Nowell and Ames families, and to Frank Nowell's nephews, Roger Nowell and Robert Curry, who generously shared their family memories.

For anyone who wishes to see more of Frank H. Nowell's work, the definitive guide to his A-Y-P photograph collection can be found in the online "Guide to the Frank H. Nowell Alaska-Yukon-Pacific Exposition Photographs." The University of Washington has a collection of Nowell's Alaska photographs and a small collection of Nowell's 1894 Montana scenes, which may be his earliest surviving work. Seattle's Museum of History and Industry also has 178 of Nowell's glass-plate negatives from the A-Y-P.

Nicolette Bromberg
March 2009

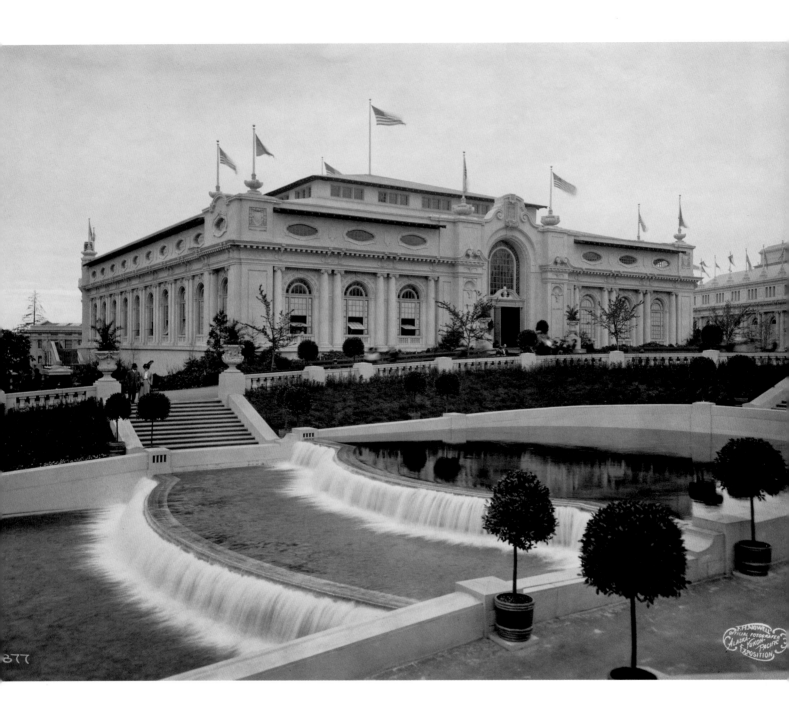

· **FIGURE I** ·
Alaska Building, 1909.
PHOTO BY FRANK H. NOWELL.
UNIVERSITY OF WASHINGTON LIBRARIES,
SPECIAL COLLECTIONS, NOWELL XI877.

PICTURING THE ALASKA-YUKON-PACIFIC EXPOSITION

THE PHOTOGRAPHS OF FRANK H. NOWELL

· BY NICOLETTE BROMBERG ·

Sitting under this spell, it is hard for us to realize that the cita-del which you set in stars beyond the lake, and which made the glory of our summer nights, has long since become a shadow across our sky; it is hard for us to believe that those graceful temples, those firelit waters, those magic gardens may soon return to the wilderness from which your genius charmed them, or to the unpoetic walks of daily commerce; harder, still, is it for us to believe that the lesson in self-reliance, in daring enterprise, in magnificent achievement which you have taught an unbeliev-ing nation, can ever be forgotten; or that your honored names may sound but strange upon the ears of those who throng our streets in days to come. Yet well we know that all such memories must go the road of the unremembered past.

—*Clarence Bagley, 1909*[1]

For those who experienced it, the Alaska-Yukon-Pacific Exposition (A-Y-P) was a summer of wonder in a "citadel . . . set in stars"—a grand world's fair that transformed Seattle's summer of 1909 into a whirl of exciting and pleasur-able days. For a short time this brash young city demanded a place in the national scene that would prove it equal to the mature and sophisticated cities in the East. On the Uni-versity of Washington campus, a huge city briefly appeared —a metropolis of the imagination, full of possibilities and marvels—very different from the real city of Seattle just to the south. At noon on June 1, 1909, horns and whistles blew, flags waved, confetti was tossed, and the gates were opened to an excited crowd of about eighty thousand fairgoers. The days of that summer at the Alaska-Yukon-Pacific Exposition offered something for everyone, from boisterous politics and fine culture to chicanery, excess, and excitement. At the end of the evening on October 16, 1909, the fair was over and the magical city became a memory for the 3.7 million visitors.

As Seattle settles into the twenty-first century, many may not have even heard of the Alaska-Yukon-Pacific Exposi-tion. The fair visitors in 1909 took away their experiences in their memories, but for those of us looking back a hundred years later, the best way to share their experience is through photographs. Photography played an important role in the A-Y-P (and other fairs); while photography was common in 1909, it was not as pervasive as it is today. We live in a world surrounded by images made by cameras that are easy to use,

9

but in the early 1900s making a photograph was a deliberate and time-consuming task. Amateur cameras and flexible film negatives were relatively new products; the first mass-market camera for the amateur, the Kodak Brownie, was introduced to the public in 1900. Because film did not have the crisp detail and quality of the glass-plate negative, most commercial photographers were still using the latter at the time of the A-Y-P. Although photography was not used as much for advertising and news in 1909, the fair promoters understood the importance of having a professional photographer to help publicize and document the exposition.

By far the best record of the fair was made by Frank H. Nowell, the official photographer for the exposition. He documented the construction, buildings, grounds, people, and activities at the fair, making four to five thousand photographs during 1908 and 1909. He used a large view camera and 8" × 10" glass-plate negatives to create his photographs. The photographs were widely used to publicize the fair both before and during that memorable summer. His photographs appeared in newspapers and magazines around the Northwest and Alaska and even in articles published on the East Coast and overseas. They were used in many souvenir books and guidebooks available for sale, which helped the fairgoers navigate the A-Y-P and take home mementos to share with others. Many people who could not attend the fair in 1909 experienced it through seeing Nowell's photographs in newspapers, postcards, or souvenir books. Of the thousands of photographs Nowell made of the exposition, the largest remaining collection is about nine hundred original prints preserved in the University of Washington Libraries, on the campus where the fair took place.

THE KLONDIKE GOLD RUSH

If it hadn't been real, it could have been a scene out of a movie. The Klondike Gold Rush began with the arrival of the steamship *Portland* at the Seattle docks on July 17, 1897, where people swarmed to see it—the gold fever had begun. The *Portland* carried a cargo of gold found in the Klondike River area of Canada's Yukon Territory. With the arrival of the gold, this modest town on the western edge of the American continent changed overnight. Even before the ship arrived that day, the early edition of the *Seattle Post-Intelligencer* screamed out the headline:

GOLD! GOLD! GOLD! GOLD!

Sixty-eight Rich Men on the Steamer Portland

STACKS OF YELLOW METAL!
Some Have $5,000, Many Have More
A Few Bring Out $100,000 Each
THE STEAMER CARRIES $700,000

That morning the wharf was jammed with throngs who had gathered to meet the ship, and by the end of the day workers were quitting their jobs. Within a few days over a thousand people left for Alaska and the Klondike gold fields in Canada. The mayor of Seattle, William Wood, who was in San Francisco at that time, immediately sent in his resignation and boarded a ship to Alaska. Crowds of eager prospectors poured through Seattle on their way to the gold fields. In the first three months of 1898, according to the *Seattle Trade Register*, fifteen thousand people flowed through the city. The prospectors faced many hardships, including an exhausting and cold trek through the mountains into Canada and up the Yukon River to the Klondike region, and most of them actually arrived too late to strike it rich. Seattle, however, struck gold as the provider of transportation, food, clothing, and equipment for the miners. All kinds of individuals and businesses benefited, including farmers, hotels, restaurants, ship builders, general merchandise suppliers, transportation companies, and banks. The 1909 exposition was the outgrowth of the economic relationship between Alaska and Seattle that began that day.

In response to an aggressive advertising campaign put on by the Seattle Chamber of Commerce, about three-fourths of the would-be prospectors decided to use the city as their starting point for the Klondike. Seattle received five times more advertising exposure than other cities on the West Coast: "Few public relations campaigns in American history could match the advertising blitz organized by the Seattle Chamber of Commerce during the stampede to the Yukon and Alaska. As a result of that marketing effort, Seattle became linked to Alaska and the Far North in the public mind."[2] Revenue passing through Seattle banks jumped from $36 million in 1897 to over $100 million in 1899.[3] Other gold discoveries in the Yukon and in the Fairbanks and Nome regions of Alaska continued to draw prospectors north to find their fortunes. About a hundred thousand gold seekers went north, about seventy thousand of whom passed through Seattle.[4] Afterwards many

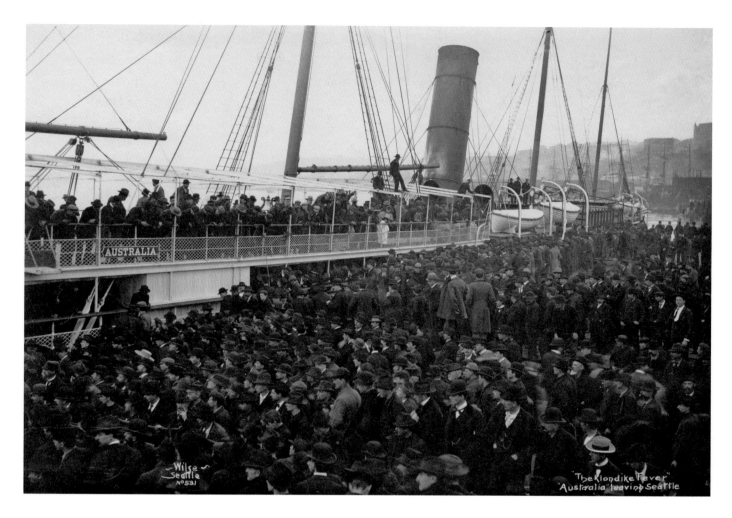

· **FIGURE 2** ·
Steamship *Australia* leaving Seattle
for Alaska, ca. 1898.
PHOTO BY ANDERS WILSE.
UNIVERSITY OF WASHINGTON LIBRARIES,
SPECIAL COLLECTIONS, WILSE 531.

of the former prospectors came back to live in Seattle or Washington State. If they were rich they brought their wealth to Seattle; if they were poor they brought photographs and memories of their adventures and lasting connections with the North. They remained in touch with their fellow adventurers through organizations such as the Arctic Brotherhood and the Alaska Club. Many Alaska businessmen came to Seattle regularly for supplies or business concerns; others came "out" for the winter to avoid being confined in their Alaskan towns by ice and snow.

Seattle began to advertise itself as "The Gateway to Alaska and the Orient,"[5] and the Seattle business community remained invested in maintaining ties with and encouraging economic development in Alaska. As the gold stampede died down, promoting Alaskan interests remained on the minds of Seattle businessmen. In 1905, an exciting new idea came to Seattle: a trade exposition. Such expositions, venues for promoting products and resources, had become a popular method for cities around the United States and elsewhere to promote their region and attract tourism and new commerce.

A FAIR IS BORN

The A-Y-P was a natural successor in a long line of trade expositions starting with the Crystal Palace Exhibition in London in 1851. The most successful and well-known American exposition was the Chicago World's Columbian Exposition in 1893, often referred to as the "White City" because of the gleaming white stucco buildings that were meant by the designers to represent the ideal city. By the time of the Chicago World's Fair, world trade expositions or world's fairs had developed to include a combination of serious exhibits, conferences, lectures, and sporting events side by side with midway amusements and exotic entertainments. This combination of culture and showmanship featured marvelous new technological innovations such as the Ferris wheel, electric lighting, and the baby incubator along with new consumer products and exhibits of the worlds of commerce and manufacturing, science and nature, fine art and agriculture. In modern terms the world's fair has been compared to "a combination of the Olympics, DisneyWorld, the Superbowl, and the National Gallery—an international entertainment and cultural event with lasting social importance."[6] Putting on an exposition demonstrated that a city had enough economic and cultural force to be of national importance.

It was almost inevitable that Seattle would host a world's fair after Portland, its rival to the south, held the Lewis and Clark Centennial American Pacific Exposition and Oriental Fair in 1905. As part of the preparation for the Lewis and Clark Exposition, John G. Brady, governor of Alaska Territory, hired Godfrey Chealander, a member of the Arctic Brotherhood who had lived in Alaska, to travel around the territory and collect exhibits. At the fair, Chealander was impressed by how popular the Alaska exhibit was and came to believe that it should be kept on permanent display. At the close of the fair, he brought his idea to William Sheffield, then secretary of Seattle's Alaska Club. Sheffield introduced him to James Wood, the city editor of the *Seattle Times*. In Wood's office at the newspaper, they discussed the idea of bringing the Alaska exhibit to Seattle. As historian Clarence Bagley related it, their conversation went thus:

> "Jim," said Sheffield, "do you want to get hold of a good story? I don't know what you may think of it, but I believe I have a first class one here. It may amount to a whole lot and it may not." "Let's hear it," Wood replied.

Sheffield then introduced Chealander, who told of the success of the Portland exhibit, outlined their plan for a permanent Alaska building and exhibit in Seattle. Before long Wood interrupted. "If Portland can have a successful Lewis & Clark Exposition, what's the matter with us? Why can't we have an Alaska exposition in Seattle which will be even more successful?" Sheffield and Chealander looked at each other and wondered "why not?" The more the three men discussed their idea the larger it grew in proportions, until by the time the interview closed an Alaska exposition in Seattle was a fact as far as they were concerned.[7]

Sheffield took the idea of an Alaskan exposition to the Alaska Club, whose members presented it to the Chamber of Commerce. The idea caught on rapidly—so rapidly that the Alaska Exposition evolved quickly into the Alaska-Yukon Exposition, since there was also an obvious connection with the Yukon. The promoters began a publicity campaign for their project which was helped by the enthusiastic support of James Wood. Wood filled the *Seattle Times* with stories about the exposition idea and interviews with influential business leaders supporting the plan. On May 7, 1906, a group of interested businessmen met at a luncheon and within a month had formed an association for the exposition. J. E. Chilberg was the president, and the three vice-presidents were John H. McGraw, A. S. Kerry, and H. C. Henry. Ira Nadeau, who had been the general agent for the Northern Pacific Railroad, was chosen to be the director general.[8]

In the beginning, the intention was to hold the fair in 1907, to coincide with the tenth anniversary of the beginning of the Klondike Gold Rush; however, Jamestown, Virginia, was planning a fair for that year to celebrate the three hundredth anniversary of its founding so Seattle's fair was postponed to 1909. This proved to be beneficial for the project since there was more time to plan and to raise funds. The next major change in the project was to expand the fair from just a regional Alaskan exhibition to a genuine "world's fair" that would feature all the countries bordering the Pacific Ocean, thereby attracting a wider audience. Thus the fair became the Alaska-Yukon-Pacific Exposition. The addition of the Pacific Rim countries and islands was a logical step since Asia and the Pacific Rim provided another market that Seattle could tap for a trade connection. As the fair was going to advertise Alaska

as a prime resource for trade, promoting access to Asian markets through Seattle also seemed like a good approach. This idea was to help position Seattle as the center of a large new market for trade expansion: "Seattle has assumed the task of introducing the half of the world which is developed almost to the ultimate, to that other half which to all intents and purposes of trade, is developed not at all."[9]

The purpose of the fair was to focus national attention on a city that was located in an out-of-the-way corner of the country far from the movers and shakers of the national scene: "The work of the A-Y-P is educational. It will impart instruction to many thousands of people who otherwise might never learn anything about the Northwest and Alaska."[10] The organizers needed some reason to argue that this fair was unique, particularly because many exhibits and amusements traveled from one venue to another. Indeed, much of the content of the A-Y-P was recycled from previous fairs, although for most Seattleites, who had not seen other fairs, it would seem new and exciting. As the change in the date of the fair meant it could not be a commemoration of an earlier event, the backers used this to their advantage by claiming the fair was unique because it was meant to look to the future rather than to the past. The exposition was to celebrate Seattle's economic potential and future as a trade center for the northern and eastern markets: "The Alaska-Yukon-Pacific Exposition does not commemorate, or celebrate, any particular event. It does not depend upon historical sentiment for its success. Aiming as it does to attain the ends in view, it will be simply a great international commercial exposition."[11]

One of the goals of the fair was to demonstrate that Seattle had grown up and was not an unrefined western backwater. Reflecting on westerners' sense of inadequacy about their place in the national culture, the president of Whitman College, Rev. Stephen Penrose, saw the fair as a way to change the perceptions of easterners about the west as a "crude, good-souled, but noisy giant, with an ineffable local conceit and no sense of proportion."[12] Historian Edmond Meany concurred with this notion of the fair as a demonstration of Seattle as a mature and cultured city, and he also pointed out that the fair was unique because it combined a setting of natural beauty with urban culture: "No other fair has been builded [sic] in a virgin forest in the heart of a cosmopolitan city."[13]

The idea of the fair was a spectacular success with the people of Seattle, who raised more than five hundred thousand dollars in subscriptions in one day on October 2, 1906. The fair backers then made appeals for support to the state and federal governments. The federal government made a six-hundred-thousand-dollar appropriation specifically for the government buildings and their exhibits—the U.S. Government Building; the Hawaii, Philippines, and Alaska buildings; and the U.S. Life Saving Station on the edge of Lake Washington. The state of Washington provided a million dollars, which was mainly designated for the several buildings meant to be permanent structures for the use of the university after the fair. The city of Seattle also had to raise much of the money, because the city would need to provide water, lighting, fire and police protection, and transportation for the event. With these resources, the fair was a reality and the work began to make it happen.

FRANK H. NOWELL

As they set out to build the fair, the promoters realized early on that they needed to have an official photographer to promote the exposition and help people envision a unique event they would eagerly want to see. On the surface, Frank H. Nowell would not have seemed the most likely candidate for the position. He had only been a commercial photographer for a few years, and his studio was located far away in Nome, Alaska. As it would turn out, however, his talent, connections, and business savvy made him a good choice.

Frank Hamilton Nowell was born in the seaport town of Portsmouth, New Hampshire, on February 19, 1864, the fourth of seven sons born to Thomas and Lydia Nowell. The Nowells were a prominent family who traced their roots back for many generations in New England. Peter Nowell came to New England from the Isle of Jersey in the 1600s. Frank's great-grandfather, Jonathan Nowell, served in the Revolutionary War in the Massachusetts Militia, and his grandfather, Henry Nowell, lived in the Longfellow house in Cambridge for many years.[14] His father, Thomas Shepard Nowell, was born on October 30, 1832, and was the first child ever christened in the Thomas Shepard Congregational Church in Cambridge, Massachusetts, after which he was named. Oliver Wendell Holmes held the infant Thomas in his arms for the christening.[15]

Thomas Nowell was a highly successful businessman who had a great impact on the lives of his sons, most of whom worked for him at various times. He loved the arts and

music and was a great supporter of his community. Nowell had a wholesale shoe-manufacturing business with a factory in Portsmouth and an outlet in Boston. He eventually left his Portsmouth business and moved to Boston, where he manufactured printing presses.[16] Although he lost his business and more than a million dollars in the 1872 Boston fire, he was able to pay off his creditors and rebuild his fortune. Thomas Nowell's success in business very likely gave his son Frank the confidence to be unworried about money and to try out his own various ventures.

The Nowell brothers were talented and successful. Three of them attended Harvard, and two of Frank's older brothers were accomplished musicians. George M. Nowell became a pianist and Willis a violinist. The composer Henry Holden Huss asked Willis to play his composition for the All American Concert at the Paris Exposition of 1889, telling him, "You are the one violinist in American that I want to play it."[17] George M. Nowell continued to play the piano but eventually became a lawyer. In 1891, he married Anna Lee Ames, the daughter of Governor Oliver Ames of Massachusetts.

Thomas Nowell liked to try new business ventures. In the 1870s, he acquired a large ranch in the O'Fallons area of Nebraska not far from North Platte where Buffalo Bill Cody lived. In 1878, Frank's oldest brother, Frederick, went out to manage his father's ranch, which was one of the first to import Holstein cattle. Shortly thereafter, when Frank was about fourteen, his father sent him out west to work for his brother. The ranch was situated along the Fremont Trail, and in his later years Frank remembered that covered-wagon caravans would pass by and that he "met and knew many of the old west's noted characters."[18] It is possible that Frederick and Frank attended the North Platte Fourth of July celebration in 1882, where Cody tried out a prototype of what would become his Wild West Show with an event called "The Old Glory Blowout." While Nowell was on his brother's ranch, buffalo were still roaming the nearby plains. Frederick Nowell obtained some buffalo, and in 1888 he sold four of them for four hundred dollars to Eugene Blackford, who presented them to the Smithsonian National Museum for their "department of living animals." They became the nucleus of a herd to be kept in Washington, DC,[19] at what would eventually become the Smithsonian's National Zoological Park.

In 1880, while Frank Nowell was living in Nebraska, the first big gold strike in Alaska was made in the Silver Bow Basin

near what would become Juneau. His father's brother, George Nowell, was operating a saloon in Sitka. After the saloon was raided by the collector of customs, George Nowell closed the business down and moved to Juneau to try his hand at mining.[20] Another of Frank's uncles, Benjamin Nowell, was also in Alaska, and they persuaded Frank's father to join them. So in June 1885, Thomas Nowell went from Boston to Alaska to try the mining business. He traveled to Juneau on a steamboat along with the newly appointed territorial governor, Alfred P. Swineford.[21] Once there, he quickly started a mining company by purchasing a group of claims originally known as the "Groundhog," located in the Silver Bow Basin about five miles from Juneau.[22] By 1889, he had consolidated a number of claims and formed the Silver Bow Basin Mining Company, the first of several mining operations he would own.

JUNEAU, NOME, AND TELLER

Apparently life in Nebraska was not exciting enough for Frank. In 1886, at age twenty-one, he decided to go to Juneau to start a dairy farm. He traveled from Seattle to Juneau on the *S. S. Ancon*, a local side-wheel steamship that served on the southeastern Alaska transportation route, traveling up and down the coast bringing passengers, mail, and supplies from Seattle. Frank brought along six cows and a bull to start a dairy herd. The cost of a round-trip fare on the *Ancon* at that time was forty dollars; Frank's one-way trip plus livestock must have cost about that much.[23]

By the next year, a local newspaper reporter described a visit to Frank's ranch, which was about a mile north of town: "Frank has a good location for his business and has spent considerable time and money in fixing it up. He has built a small dwelling house and a good frame barn and otherwise improved the looks of the place. In the lower part of the barn we found six first-class milch cows, all in good condition, and giving plenty of milk."[24] Although Frank was successful at the dairy business, he must not have liked it. By June 1887, his property and cows were up for sale and by July he had sold the cows.[25] He was having some health problems and left Juneau in October to go to the States to recuperate. When he returned the following summer on the *Ancon*, he went to work managing some of his father's mining concerns. Perhaps feeling restless, he tried out a variety of other enterprises. In June 1889 he had two horses shipped up, and in May 1890 he bought

· **FIGURE 3** ·
Thomas Nowell, Willis Nowell,
Tom Cobb, Frank H. Nowell,
and George Nowell in Juneau,
ca. 1890s.
ALASKA STATE LIBRARY, NOWELL FAMILY
PHOTOGRAPH COLLECTION, PCA 402.7.

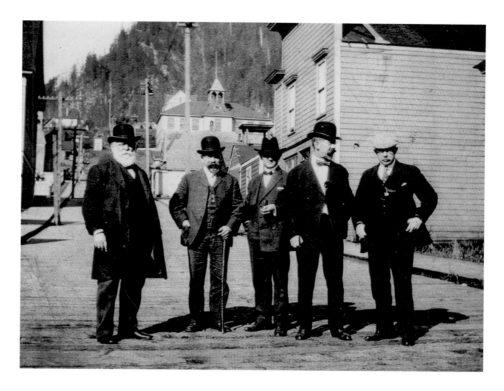

· **FIGURE 3** ·
Thomas Nowell, Willis Nowell,
Tom Cobb, Frank H. Nowell,
and George Nowell in Juneau,
ca. 1890s.
ALASKA STATE LIBRARY, NOWELL FAMILY
PHOTOGRAPH COLLECTION, PCA 402.7.

out the general hauling and draying business belonging to Archibald Burns, advertising his new business as the Alaska Dray Company. He also became an agent for the Giant Powder & Gelatine Dynamite Company of San Francisco. Although he experimented with a number of occupations, he continued to return to help his father in the mining business.

Running the Nowell mining interests in the Juneau area was a family affair. Thomas Nowell kept his residence in Boston and traveled back and forth to check on his companies, while his sons helped manage the operations in Juneau. In July 1890, the newspaper noted that Frank was going to be the "general financial manager for both the Silver Bow Basin Mining Company and the Nowell Gold Mining Company."[26] Other family members also helped out. A cousin came out to manage the Silver Bow Basin Mining Company during the winter of 1890, and in the spring Frank's older brother Frederick arrived to take over the duties of managing the company. Frederick remained active in the various local family businesses, including helping to manage the Nowell Brothers general store with their brother Willis, who also became the Juneau agent for the Alaska Steamship Company. Later Frank's younger brothers Arthur and Harrison also spent time working with their father's mining companies in Juneau.

Thomas Nowell and his sons were good businessmen and were clearly well regarded by the community. In October 1889, Frank was elected to be one of seven delegates to the territorial convention held in Juneau in November.[27] His father was so well respected in Juneau and had so many connections with officials and members of Congress in Washington, DC, that in the fall of 1892 he was unanimously chosen as one of two Alaska delegates to the Republican convention held in Minnesota. Although Alaska did not have a vote at the convention, Thomas gave such a forceful speech that the convention unanimously agreed to grant a seat on the floor to the two delegates from Alaska, making them the first representatives from the territory to vote at a national convention.[28] Frank Nowell's ease with the business community likely came from his father's example, which was also probably a contributing factor to his selection as the official photographer for the A-Y-P.

While Nowell was involved with mining and his side businesses, he had something else that was also occupying his mind. Sometime in the early 1890s, he became interested in photography, and on one of his trips to the East Coast he took it up as a hobby. He apparently found great enjoyment in it and was not shy about photographing people. Nowell had grown to be a large, rather imposing-looking man but his

fun-loving and genial nature probably put people at ease when he took their pictures. A man who was interviewed in 1908 in Fairbanks when Nowell came through on his A-Y-P photography tour remembered him as the first person he met when he came to Alaska many years before. As the man stepped off the steamboat upon his arrival in Juneau he saw Nowell with his camera: "The first thing I noticed as I started down the gang plank was an object covered with a black cloth. As I came towards it, the face of a man emerged and he greeted me with the expression, 'I got you all right.' And many times while in that part of the country, I have encountered the same figure shooting at some object; and the development of his plates invariably disclosed a picture of merit. [Years later] I ran across him in Teller when the mercury was many degrees below zero. He had inveigled a party of fur-clothed esquimaux to stand for their picture."[29]

When he was on a vacation in Florida, probably in 1893 or 1894, Nowell met and fell in love with Elizabeth Helen Davis, whose father, Alonzo C. Davis, was superintendent and part owner of a mine in Calumet, Michigan. Even during this time, Nowell maintained his excitement about photography. His daughter Dorothy recalled, "At the time my mother and father met in Florida, he was interested in photography as a hobby only—as mother said she spent most of her courtship and honeymoon in improvised dark-rooms while father developed the pictures he was constantly taking."[30]

It is not clear where Nowell learned his photographic skills, but one possible source was a distant relative. Frank Augustus Nowell was a photographer who was born in Portsmouth, New Hampshire, in 1847, which made him fifteen years older than Frank Hamilton Nowell. They were not directly related but shared a distant ancestor. Frank A. Nowell ran a photography studio in Charleston, South Carolina, in the 1880s and then moved to Pittsfield, Massachusetts, in the 1890s. Frank H. Nowell is said to have learned photography while visiting in the East, so if he knew Frank A., he may have been introduced to the subject by him. (Frank H. Nowell usually went by F. H. or Frank H. One writer has noted about the use of middle names, "It's a big extended family thing . . . where everybody in the family is named after everybody else in the family. It's the middle names that let everyone sort out exactly who's who.")[31]

However he learned photography, Frank H. Nowell was enthusiastically practicing it at the time of his marriage. He and his wife were married at the home of her brother, William B. Davis, in Helena, Montana, in 1894. They honeymooned in Montana for a while. Nowell joined the Elks while he was there and also made photographs at a mine, including one of himself and his brother-in-law in the entrance. He signed the photograph, "Frank Hamilton Nowell, Amateur Photographer, Gould, Montana."

Nowell and his wife then moved to the Bay Area in California, where they lived in various places—in Pacific Grove, where their daughter, Dorothy, was born on June 6, 1895, and in Oakland and San Francisco. He was listed in the 1897 San Francisco City Directory as a mining agent with an office in the Crocker Building, and he was settled enough to transfer his Elks membership to San Francisco and join the San Francisco branch of the Sons of the Revolution. Like his father, who continued to travel between Boston and Juneau, Frank spent his time between California and Juneau, working for his father's mining company. The 1898 *Miner's Manual* reported that there was a "consolidation of a large number of claims in the Silver Bow Basin Mining Company under the management of F. H. Nowell."[32] His work included overseeing the construction of a huge tunnel to carry a flume into the Silver Bow Basin.[33] The consolidated company became the Nowell Gold Mining Company. The manual noted, "The company gives employment to 20 white men and 22 Indians. The former receive $2.50 per day and their board. Indian laborers receive $2.50 and board themselves."[34]

Nowell continued to photograph, sometimes combining his hobby with work. When he wrote his father about a mine in Siskiyou County, California, that he and his brother Harrison were managing—"This is a wonderful mine and people are beginning to talk a great deal about it"[35]—he also sent photographs. His father wrote back thanking him: "The photographs that you sent me came to hand in perfect condition and I assure you they gave me a splendid idea of the situation . . . the picture that leads from the Manager's residence to the mine shows a very beautiful country, quite a contrast between that and Alaska I can assure you. These photographs will be of great assistance to me in explaining the position of things."[36]

While Nowell was traveling back and forth from San Francisco working for his father, the Klondike Gold Rush was in full swing, with would-be prospectors swarming to the gold fields around Dawson in the Yukon Territory of Canada. The

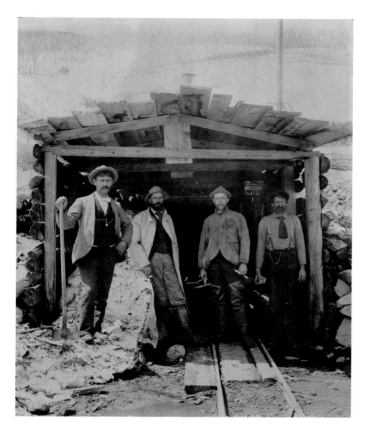

· **FIGURE 4** ·
Frank H. Nowell, W. B. Davis, and two men
at entrance to mine in Montana, 1894.
PHOTO BY FRANK H. NOWELL. UNIVERSITY OF WASHINGTON
LIBRARIES, SPECIAL COLLECTIONS, UW28130Z.

two competing routes to the gold fields required the prospectors to travel either over the Chilkoot Pass starting in Dyea or over the White Pass starting in Skagway, a few miles away. The two towns were on the coast about a hundred miles north of Juneau. The Royal Canadian Mounted Police stationed at the border passes required the prospectors traveling into Canada to bring a year's worth of provisions. They had to carry their goods over the passes by a difficult trek on foot. In Dyea, a man named Archie Burns[37] established a horse-powered tram that could haul freight partway up the Chilkoot Pass, and by February 1898 he was hauling five tons of freight over the pass daily. During this time Nowell was traveling to Dyea bringing cable and other supplies from San Francisco for the construction of a competing tram by the Dyea-Klondike Transportation Company, another of his father's business enterprises.

The tramway opened on March 17, 1898, with the claim that it was "the only tramway in the world powered by electricity."[38] A few months later the Dyea-Klondike Transportation Company merged with two other competing tram companies to become the Chilkoot Railroad and Transport Company. This company was to be short-lived, however, because in rival Skagway an actual railroad was being constructed over the White Pass. Nowell was on hand for the ceremonial first trip of the White Pass and Yukon Railroad to the summit of White Pass. There were one hundred guests invited to the event. The train left Skagway February 20, 1899, on a windy, four-degrees-below-zero day and slowly climbed up to the pass. It got even colder as they ascended, but that didn't deter the participants from photographing along the way as the train made many stops for picture-taking opportunities. The *Daily Alaskan* reported that "there were enough cameras along to start a camera club."[39]

While it became easier to get to the Klondike gold region, most prospectors were too late to find anything. The gold fever persisted, however, so gold seekers moved out of the Yukon and into Alaska, searching in Fairbanks and other inland regions. In 1899, gold was found on Anvil Creek near Nome, and then on the nearby beaches. In 1900 a massive stampede began for Nome: "Nome erupted into maturity. One moment it was a deserted stretch of Alaskan coastline on the Norton Sound; the next it was so white with tents set peg-to-peg that the landscape appeared to be snow-covered. And it was one of the most desolate places on earth. Located two thousand miles north of Seattle, the strike was located in treeless, flat country that saw fewer than 120 days a year of ice-free ocean for steamship travel—June 1 to October 1."[40]

Nome was located far north in the Bering Sea and was inaccessible during the winter months when the sea was covered with ice. The route to Nome was about twenty-seven hundred miles by ship from Seattle, which was much easier than the arduous trek to the Klondike gold fields and the northeastern areas of Alaska. The Nome-bound prospector just had to find passage on a steamship, pay the hundred-dollar first-class or seventy-five-dollar second-class fee, and survive the trip of about ten days.[41] The first ships were able to leave Seattle in April 1900. By May, Seattle was crowded with stampeders waiting to get on a ship. There may have been as many as twenty thousand people in the city that month trying to get passage to Nome.

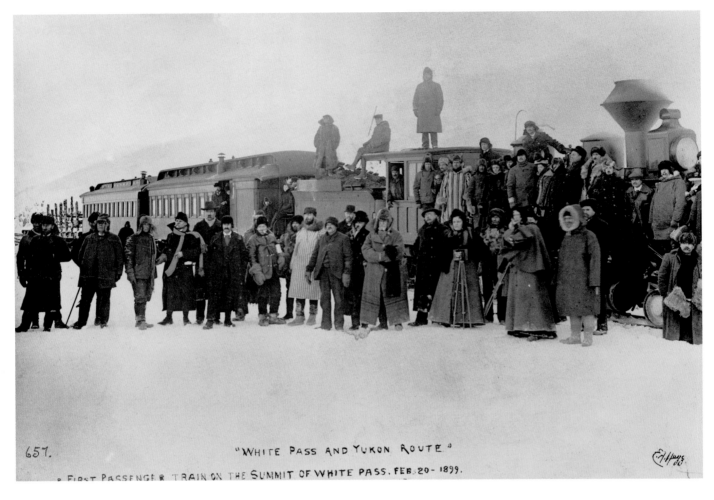

"WHITE PASS AND YUKON ROUTE."

657.

FIRST PASSENGER TRAIN ON THE SUMMIT OF WHITE PASS. FEB. 20- 1899.

· **FIGURE 5** ·
First passenger train of the White Pass
and Yukon Railroad at the summit
of White Pass, February 20, 1899.
PHOTO BY ERIC HEGG.
UNIVERSITY OF WASHINGTON LIBRARIES,
SPECIAL COLLECTIONS, HEGG 657.

During May and June about thirty steamers left Seattle, carrying around eleven thousand passengers.[42] Since Nome was so far north and away from any supply routes, most supplies had to be shipped, so the steamers carried tons of mining machinery and supplies along with the passengers. In the month of June alone, about six hundred thousand tons of freight arrived in Nome. Because there were no ready supplies in the town, the prices for goods were two to five times higher than in Seattle or San Francisco.[43] In addition to the harsh climate that limited the days of travel, the harbor of Nome was too shallow for the ships to land at the shore to unload. All passengers and supplies had to be lightered in (brought in on a barge) from the ships, which remained about a mile out: "It cost as much to carry a load of freight the last mile through the surf to the shore, as it had cost to transport it more than two thousand miles from Seattle."[44]

Selling supplies in Nome to the scores of miners was a profitable business. The Ames Mercantile Company of San Francisco, which had a store in Dawson during the Klondike Gold Rush, opened another in Nome, and Nowell was offered a job working there. He may have wanted to take a break from working for his father in the mining business or perhaps just wanted a bit of adventure. In any case, he accepted the job at the new Ames Mercantile store. He may have already been preparing to leave his family for Nome by June 1900, because he

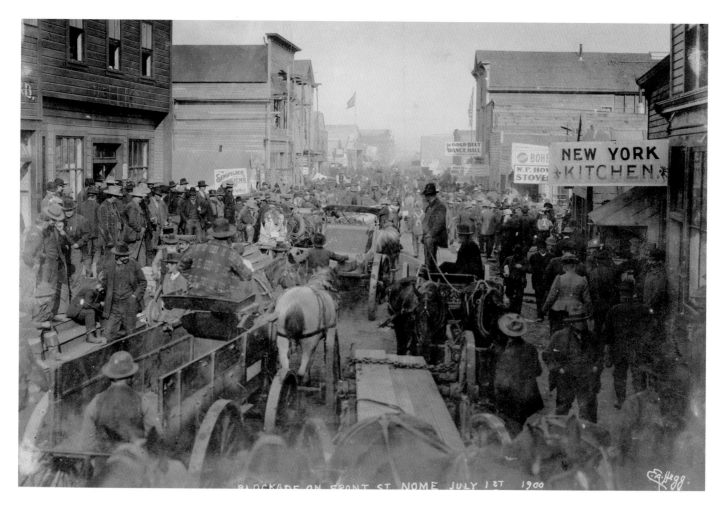

BLOCKADE ON FRONT ST NOME JULY 1st 1900

was living in the Hotel Savoy in San Francisco while his wife and daughter were living in a boardinghouse on Post Street, according to the 1900 census carried out in June that year.[45] It is likely that he was waiting to get passage on a ship to Nome. The census listed him as a secretary of a mining company, so he may have thought that he would go to Nome just to take a break, not knowing if he would stay. He probably arrived in Nome by July, when the town was overwhelmed with gold-seekers jamming the streets. On his arrival, he found crowded and dusty streets. The city was long and narrow—only about two blocks wide and five miles long. Photographs from July 1900 show the narrow street completely filled with people. Nowell must have found it an exciting time to be there.

By the fall, Nowell was asked to set up a new branch of the store in Teller, about seventy miles from Nome. Teller was a new town that had been started in 1900 when gold was

· **FIGURE 6** ·
Front Street, Nome, Alaska, July 1, 1900.
PHOTO BY ERIC HEGG.
UNIVERSITY OF WASHINGTON LIBRARIES,
SPECIAL COLLECTIONS, HEGG 1273.

found in the area. It was located near the government reindeer station, built in 1892, when the United States imported reindeer for the Eskimos who lived in the area. The Inupiat Eskimos had a fishing camp called Nook about twenty miles south of Teller, plus a number of other camps around the area. The town served as a regional trading center for many of the natives. The Ames Company probably wanted to get the new store in place by the end of the navigation season to set up for the winter trade. Such supply companies would put in large stocks of merchandise to carry over the nine months until the opening of the shipping season.[46]

Nowell set up the store in Teller, but all was not work—he also enjoyed a good time. In March 1901 he arranged a St. Patrick's Day Masquerade Ball to help raise money to pay off some of the debts owed by the town. Sometime later, during the travel season, he arranged for his wife and child to come from San Francisco to join him. They brought along his camera, so he could now indulge in his favorite hobby. By October, when the last boat left Teller for the season, there were thirty-five white residents and about a hundred Eskimos left in town for the winter. At Christmas, when one of the white residents bemoaned the lack of a Christmas tree in their treeless region, an inventive friend made holes in an 8" × 8" square timber and filled the holes with broom, mop, and shovel handles to make branches. The community decorated the "tree" with popcorn and candles and installed it on a platform in the Monogram Saloon, where Santa Claus arrived and gave gifts to all. The local natives were invited to the celebration, and they all attended the festivities. The Christmas program featured songs and a pantomime by five little girls, including Nowell's daughter, five-year-old Dorothy. A program card for the event was printed with ads for local businesses, including Frank's latest enterprise, the Miner's Supply Company.[47]

Ever the entrepreneur, Nowell had begun to buy up and resell miners' outfits from unsuccessful prospectors and used the proceeds to start his own supply store. By August 1, 1901, the Teller newspaper announced that Nowell had left the Ames Mercantile Company and was starting a new store, in partnership with L. D. "Doc" Muller. Nowell and his partner continued to run the Miner's Supply Company during 1902 and 1903, but Nowell soon found that he was more and more interested in his photography. He was making pictures of the local natives and scenes of interest to him and he began to feel that photography was more important to him than just a hobby.

AN ALASKAN PHOTOGRAPHER

Nowell had finally found his true calling. The lure of the camera, glass-plate negatives, and developing chemicals pulled him away from sales. By the end of 1903 or in early 1904, he decided that he would open a photography studio (plate 7). Making photographs in such a harsh climate with limited access to supplies was especially challenging. Nowell used large 8" × 10" glass-plate negatives with a view camera that had to be mounted on a tripod. To go anywhere to photograph, he had

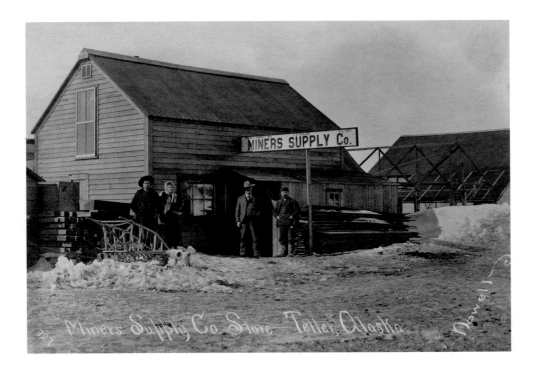

· **FIGURE 7** ·
Miner's Supply Company store
in Teller, Alaska, ca. 1902.
PHOTO BY FRANK H. NOWELL,
COURTESY OF CANDY WAUGAMAN.

to transport a large amount of heavy gear, including negative holders filled with heavy glass plates. Each holder contained only one negative. Photography with a view camera and glass plates is very time consuming: For each image, it takes time to get the camera settings just right and to compose the picture, which appears upside down to the photographer as it is being composed. The extremely cold weather could also affect the working of the camera, and exposure times for the negatives took longer than is normal today. At the end of the day, the photographer had to get the glass negatives back to the studio without breaking them. Frontier photographers such as Nowell were craftsmen and -women who depended on their skill to produce fine images in spite of the problems of working in the field. Nowell clearly had a talent and a fine natural sense of composition since his images were well designed and well executed right from the beginning.

His earliest professional work was done in 1902 at Cape Prince of Wales, located close to the islands off Siberia, among the reindeer herds in the harsh barren landscape where the Inupiat Eskimos lived north of Teller. The writer Ella Higginson, who used Nowell's photographs in her travelogue on Alaska, said of this area, "Less than a day's voyage from Nome is the westernmost point of our country—Cape Prince of Wales, the 'King-egan' of the natives. It is fifty-four miles from this cape to the East Cape of Siberia, and like stepping-stones between lie Fairway Rock and the Diomedes. Beyond is the Frozen Ocean. These islands are of almost solid stone. They are snow-swept, ice-bound, and ice-bounded for eight months of every year."[48] One of Nowell's earliest published photographs, probably taken in 1902, was the "Most Northerly Public School House in the United States, Cape Prince of Wales, Alaska" (plate 2). Sheldon Jackson reproduced the photo in *Education and Reindeer in Alaska,* the 1903 report he prepared for the U.S. Bureau of Education. The photograph shows Eskimo students and their teachers standing in the snow outside the school. One of those teachers was Orville Rognon, who had come north in 1900 with his brother Ernest, a lawyer living in Teller, and his sister, Suzanne Rognon Bernardi, the other teacher in the Wales school. Nowell may have forged a friendship with Suzanne and Orville because of a shared interest in photography. Orville was making photographs of their experiences and Suzanne created albums that she gave to friends as Christmas presents.[49] Years later, Orville would work with Frank photographing at the A-Y-P.

Nowell's early photographs show the preoccupations of life in Nome and the Seward Peninsula—mining (plates 1 and 4), social activities, the physical landscape; important events such as the first dog-sled mail run, the storm that almost destroyed Nome, the big winter snows in the streets (plate 3); and the native people who lived both nearby and among them. He photographed various activities around Nome, such as the John Sesnon Company lightering business, which brought passengers in from the boats because they could not land on the shore, and the many mining operations in the area. He also photographed the small towns around the Seward Peninsula, including Teller, Council, Candle City, Record City, and Solomon. Since his studio was situated between the Golden Gate Hotel and the Post Office in Nome, he was on hand to record the arrivals and departures of the dog-sled mail teams and the arrival of notable people such as Adolphus Washington Greeley, a retired Civil War general who became famous when his expedition to the Arctic in 1881 became lost and the survivors were not rescued until 1884. Nowell was also on hand to photograph the explorer Captain Roald Amundsen and his crew aboard the *Gjøa,* when they arrived in Nome in August 1906 (plate 5). As they steamed into Nome, Amundsen and his crew were completing the first ever successful expedition to navigate the Northwest Passage, going between the Atlantic and Pacific oceans in the Canadian Arctic.

Nowell's work became popular early on, particularly his photographs of the local Eskimos. Over the years, he made many photographs of the native people, most often in their camps or villages. They can be seen in pictures of his studio window in Nome and later around the edge of the Official Photographer Building at the A-Y-P; they were also sold at the exposition. His studio advertisements often included the statement that he specialized in Eskimo photographs. Nowell had the advantage of starting out at a time when people were used to having photographs of their travel experiences. Alaska had long been a tourist destination, although Nome could not be counted in the general tourist route. Nowell's photographs of the local Eskimos provided a look at a culture perceived as exotic and captured a sense of "otherness," considered the essence of travel. Just like the tourists, prospectors and others in the Nome region most likely wanted souvenirs of their time in Alaska, and Nowell could sell them his clear, high-quality images to take "down below" to show their families and friends.

One of his most popular pictures, made at the Cape Prince of Wales village in 1902, documented four Eskimo women posed with reindeer from the American Missionary Association herd (plate 6). This photograph was reproduced in magazines and books describing Eskimos, and Nowell also displayed it in his studio window. The *Alaska-Yukon Magazine* published stories about mining and commerce in Alaska and the Yukon, along with reminiscences or observations of life in the North. There were many articles about Eskimos and Nowell's photos were often included. The photograph of the Eskimo women with reindeer was frequently used, sometimes in sequential volumes of the magazine. Nowell's work appeared in Ed Harrison's 1905 book, *Nome and the Seward Peninsula,* Ella Higginson's travel account, *The Great Country,* and other personal memoirs and travel writing.

Nome was closely connected with Seattle and easily reached during the open season between June and October when the Bering Sea was free of ice. It was also desolate and harsh, so in the winter season many people left to go to Seattle or other cities, bringing stories of Alaska with them. Sometime around the end of the 1903 season in Nome (probably October), Nowell and his family left for Seattle. Always looking for a good picture, he made photographs of Dutch Harbor and Unalaska, which were stops on the way. Nowell had decided to move his family to Seattle permanently and by 1904 had a residence listed in the Seattle city directory. He probably moved his family to Seattle because the climate and prospects would be better for them there than in Nome. However, just as his father had maintained his residence in Boston while operating a mining business in Juneau, Nowell kept his business, the photography studio, in Nome. He had an assistant who helped run the studio, but Nowell spent many years traveling back and forth and living between the two towns.

With his family settled in Seattle, he photographed the crowds at Robinson dock seeing off the *S. S. Tacoma* as it left for Nome on June 1, 1904, and then went up to Nome later that season to resume his photography business. Nowell was a member of the newly organized Alaska Club in Seattle, a group formed to support Alaskan commercial interests in Seattle and Washington State and publicize the resources of Alaska and its commercial possibilities: "The prime objects and purposes of the Club are to maintain in Seattle a prominent exposition of Alaska's Resources, such as Agriculture, Mines and Mining, Forestry and Lumber, Fisheries and Manufactures.

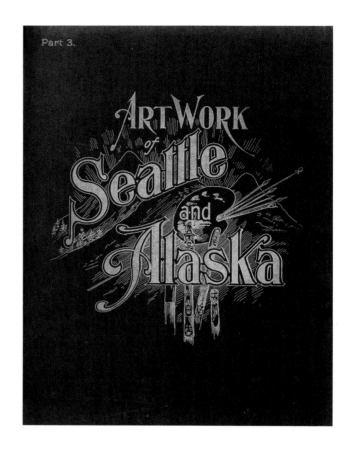

Also a Library of all information pertaining to Alaska, with Topographical Maps, Photographic Views, etc."[50] The Alaska Club had a reading room and meeting place for Alaskans along with an information bureau. Nowell's studio advertisement in Edward Harrison's 1905 book *Nome and Seward Peninsula* listed the Alaska Club as his contact information. Nowell was also a member of the Arctic Brotherhood, a fraternal group organized during the Gold Rush to help protect the rights of the prospectors.

Nowell's career was going well and it got even better. In March 1907, the *Seattle Sunday Times* ran this story: "Frank H. Nowell, of Seattle, the well-known delineator of Alaskan life and types, is planning the publication of a book setting forth in detail both in work and picture the striking things he has met in his wide wanderings over the Northern country, together with his gleanings from historical research."[51] He published a nine-volume large-format (11" × 14") set of books of about a dozen or so pages each, which together made up *Art Work of Seattle and Alaska,* published by W. D. Harney Photogravure Company of Racine, Wisconsin. The book contained

· **FIGURE 8** ·
Cover of *Art Work of Seattle and Alaska,* Nowell's 1907 book of Alaska photographs.

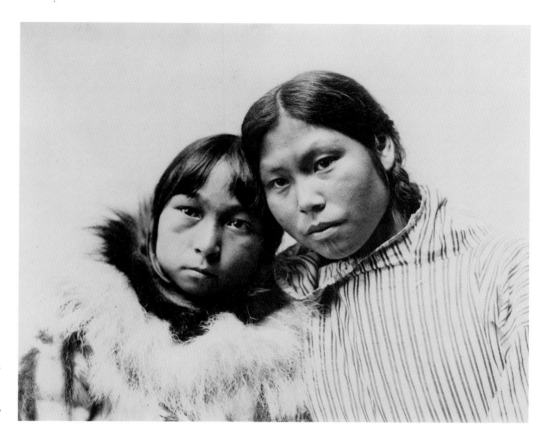

· **FIGURE 9** ·
"Eskimo Friends," illustration from *Art Work of Seattle and Alaska* by Frank H. Nowell.
UNIVERSITY OF WASHINGTON LIBRARIES, SPECIAL COLLECTIONS, UW26942Z.

a collection of fine-quality photogravures and a small amount of text. There were two essays—"Seattle and Its Environs" by W. C. Bayles and "Alaska" by Thomas Nowell, Frank's father, who moved to Seattle shortly after the publication of the book. On its title page, the book listed "associate artists," including five photographers: W. P. Romans, Asahel Curtis, Wylie Dennison, Frank H. Nowell, and Thomas W. Tolman. Most of the Alaska photographs in the book were made by Nowell. Harney made many of the photographs of western Washington and Seattle. (The other men listed contributed just a few of the photographs.) Nowell's photogravures of Alaska were printed in a brown tone, and the photographs of Washington in green and blue tones.

OFFICIAL PHOTOGRAPHER OF THE ALASKA-YUKON-PACIFIC EXPOSITION

Nowell's success was reflected in his 1907 advertisement, which made grand claims for his work: "Our Line of Alaska Views and Eskimo Studies Is Unsurpassed." He was about to

become even more successful. As the A-Y-P was being planned, officials realized that they needed to have an official photographer to document the exposition construction and fair events for publicity and other purposes. There is no record of their discussion on the matter, but they chose Frank Nowell. While Nowell was an excellent photographer, he might not have been the obvious choice, owing to his limited experience as a commercial photographer, his brief residence in Seattle, and the fact that his photography studio was located in Nome. There were a number of excellent Seattle photographers who could have been considered strong candidates, such as Asahel Curtis, Webster & Stevens, and William Romans, who had well-established commercial studios in Seattle and had considerable experience documenting the city. Seattle and western Washington had a very active photography scene. As businessmen the A-Y-P officials would probably have used the services of some of the local photographers, a number of whom had been in Alaska and/or the Yukon. Eric Hegg (who was a member of the Alaska Club and undoubtedly knew Nowell), Frank La Roche, Asahel Curtis, Webster & Stevens,

and Arthur Churchill Warner had photographed in the gold fields and throughout Alaska. (Edward Curtis had also been briefly in Alaska but was engaged on his project on the North American Indian.) There were other good commercial photographers in town, many of whom had also been in partnerships at various times over the years.

What Nowell probably had over the more established Seattle photographers were the connections resulting from his memberships in the Alaska Club and the Arctic Brotherhood. These business connections, and the ease and familiarity with high-powered businessmen Nowell learned from his father, undoubtedly helped his case. Nowell certainly would have known A-Y-P association president J. E. Chilberg, since Chilberg was the president of the Nome Miners & Merchants Bank, which Nowell photographed in 1905. Nowell had probably met many other A-Y-P officials through the Alaska Club and Arctic Brotherhood. Even members who did not know Nowell personally must have been familiar with his work: his photographs would have been in the Alaska Club library; the book *Art Work of Seattle and Alaska* included a large number of exquisite photogravures of his Alaska images; and he came with a collection of other Alaska images on hand, which would be important since the fair was to celebrate Alaska and its resources. Nowell may even have known about the idea of a Seattle fair early on, because when Godfrey Chealander wrote to Chilberg in 1905 he was in Nome staying at the Golden Gate Hotel next door to Nowell's studio.[52]

Whatever the reasons he was hired, Nowell documented the fair's June 1, 1907, groundbreaking ceremony and prepared for work over the months of construction.

BUILDING THE FAIR

The first order of business for the A-Y-P officials was to decide on a site for the fair. It had to be an area easy to reach by streetcar or train yet with enough room for the large exposition landscape. There were half a dozen proposals for the site, but the most popular was Professor Edmond Meany's idea to hold the fair on the new university campus just outside town. In 1895, the university had moved from its downtown location to 250 acres of heavily forested land north of town. Because there were only three permanent buildings on the site and the landscape had spectacular views of mountains and water, it was the perfect location for a grand fair. Meany suggested

that the state legislature allot some permanent buildings for the university to use after the fair was over, and in fact the state did give money toward four permanent buildings, thus doubling the size of the campus.[53] Meany extolled the site in *Colliers Magazine:*

> The grounds stretch between the shores of Lakes Union and Washington, with the tides of Puget Sound pulsing near. To the east rise the snow-crowned monarchs of the Cascade Range, and to the west may be seen the smaller but more jagged Olympic Mountains, like a great celestial saw cleaving the clouds. Everywhere on the distant shores and foot-hills are the primeval forests. Portions of these famed forests have been retained along the edges of the Exposition grounds. Here, then, are the dynamic forces of the West—mountains and forests, glaciers, lakes and tides—and in their midst nestles this Exposition, a dainty gem by day, a brilliant diadem by night. . . . The Seattle men, constituting the Board of Trustees, aware that their own people would bear the cost, haggled not a moment, but engaged the highest talent for all tasks, declaring that while their Exposition would be relatively small, it must be perfect in beauty, with the keynote of "life, color, and motion."[54]

Once the A-Y-P officials had agreed on the campus site, the city leased the southern half of the grounds from the University of Washington Regents and the design work began. The astounding natural beauty of the site was one of the things that would make the A-Y-P stand out from previous fairs. The administrators wanted the best, so they hired the Olmsted Brothers, a landscape architecture firm from Brookline, Massachusetts. Frederick Law Olmsted Jr. and John C. Olmsted were the son and stepson of the famous landscape designer Frederick Law Olmsted Sr. The choice seemed obvious—the Olmsteds had designed the Portland exposition site; in 1904 the University regents had engaged them to create a campus design for the university; and they had also designed Seattle's park system. It is interesting, however, that the previous Olmsted design for the campus was not very inspired, and that John C. Olmsted had said that except in limited areas retaining the site's native fir trees "was neither desirable nor practical."[55] It has been speculated that John C. Olmsted's original visit to plan the campus design took place during one of Seattle's

well-known overcast periods, and he missed the fact that the site had spectacular views of Mount Rainier.[56]

This time, when John C. Olmsted came to plan the exposition design, the weather must have been clear and the mountain was out in all its beauty. Olmsted recognized that the dramatic view of Mount Rainier had to be the centerpiece of the design. So rather than using a monument or building as the focal point, as was common in the Beaux Arts style at the time, the Olmsteds chose the mountain: "Unlike the firm's 1904 campus plan, the exposition plan was manipulated to focus its major axis and vista on the looming southerly prominence of Mount Rainier. Once that alignment had been identified, it would be the primary design control to which the rest of the plan was subservient. It was an inspired discovery, an occidental application of the Japanese shakkei (borrowed scenery) principle, which would not only bring drama to the exposition but also continue to serve splendidly the university campus."[57] This application of a Japanese design principle coincidentally tied into a theme of the exposition, which was to combine western and Asian influences. At the center of the design was Rainier Vista—a broad axis that went through the grounds from the U.S. Government Building down the Cascades waterfall to the Geyser Basin pool toward Mount Rainier. Looking up from Rainier Vista, the landscape rose from plantings to the pool and waterfall in front of the formal buildings. This meant that at one end there was a grouping of Beaux Arts buildings similar to the "White City" of the 1893 Chicago fair and at the other end the natural landscape of the forested site and mountain. The Pay Streak amusement area (named for the richest deposit of gold in a placer mine) was one long avenue running down the western side of the exposition grounds, beginning just off the main gate and ending at Lake Union. The formal plantings were concentrated in the central grounds of the site and spread out to the natural areas.

The core areas of the Cascades waterfall, Geyer Basin, and Rainier Vista had gardens and plantings that one would expect to see along with classical architecture at the center of the exposition. It was estimated that about two million plants were used on the site. The intent of the Olmsted design was to complement the natural setting, and the flowers were worked into the grounds in various degrees of formality and naturalism, culminating in the southern area of the site, where the trees and natural vegetation were retained, and plants were placed among the woods and along the lake merely to

enhance the natural setting.[58] When John Olmsted visited the site in May 1909, he described it as having "the grandest natural scenery surrounding it of any exhibit of its kind ever seen, not excepting the big Chicago World's Fair."[59]

A survey of the grounds started on February 1, 1907, and the official groundbreaking ceremony took place on June 1, in front of a crowd of about fifteen thousand people. John Barrett, the Director of the International Bureau of American Republics, spoke on behalf of President Theodore Roosevelt: "You may say in the strongest terms that I am a staunch believer in the great Pacific Northwest and the Alaska-Yukon country. It has a future of unequalled opportunity backed up by limitless resources and possibilities. Seattle and other cities of the Puget Sound are fortunate in facing the Pacific Ocean with its vast commerce, and have everything to make them great and prosperous centers of population, trade, and influence."[60] A golden ceremonial pick and shovel were used to break the ground. As president of the exposition, J. E. Chilberg had the honor of digging the first shovel of dirt after which some in the crowd got rowdy—they dashed in and grabbed handfuls of dirt, the ceremonial flags, and the bunting. During this melee someone stole the golden shovel.

After the groundbreaking day, there was just a small crew at work until August 15, when a large crew of eight hundred men was put to work. The landscape was logged and graded in preparation for construction. The first buildings to be completed were the Administration Building (plate 69A) and the Emergency Hospital (plate 70A), while various delegations visited the grounds to choose sites for their buildings (plate 10). Along with the work on the exposition grounds, the city provided funds to construct two welcome arches in the downtown area "to in some measure voice the city's welcome to our many visitors."[61]

Like most other expositions after 1893, the A-Y-P was highly influenced by the Chicago World's Fair "White City" look. The architectural firm Howard & Galloway used the French Beaux Arts classical style for the huge main exhibit buildings—the U.S. Government Building, Agriculture Building, Manufactures Building,[62] Mining Building, etc. Edouard Champney was sent to supervise the work on the project. The large important buildings were at the center of the Court of Honor and were the most classically imposing—evoking order, tradition, and grandeur (plate 12). The Arctic Circle was the central point of the fairgrounds, with one end looking

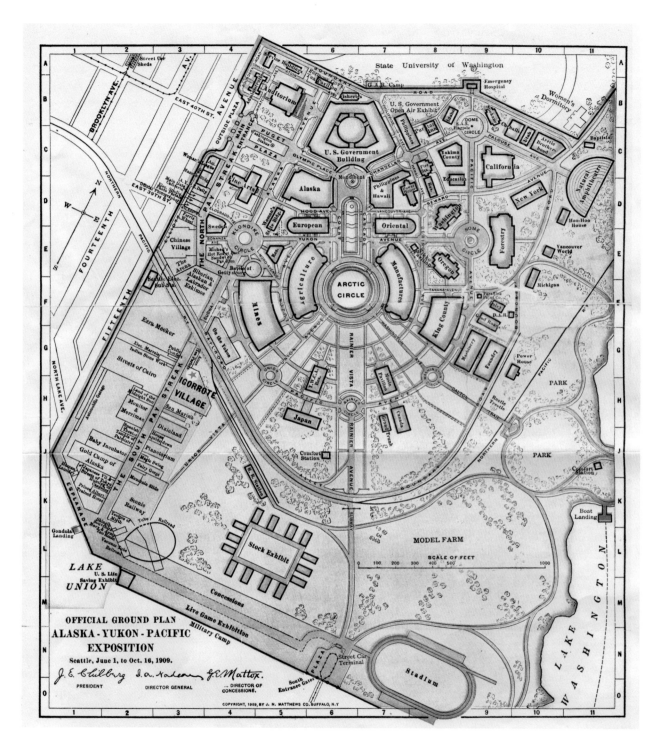

· **FIGURE 10** ·
The official A-Y-P plan, which evolved from the
Olmsted Brothers' original plan.

down Rainier Vista to the mountain. The Alaska Monument, an eighty-foot-high column covered in gold from Alaska and the Yukon, stood in front of the U.S. Government Building (plate 57A). Looking up toward the Government Building from the Arctic Circle were six major buildings flanking Geyser Basin and the Cascades waterfall. The immense Manufactures and Agriculture buildings were curved around the Arctic Circle facing the Geyser Basin. Uphill were the European and Oriental buildings that faced across the Cascades waterfall, and finally the Alaska and the Hawaii buildings faced each other in front of the U.S. Government Building. (See plates 50A–54A.) The small U.S. government–sponsored Philippines Building (plate 58A) stood tucked back to the side of the massive U.S. Government Building. Yukon Avenue crossed the Rainier Vista axis near the European and Oriental buildings. It had two smaller circles on each end. To the west, the Klondike Circle was located near the Pay Streak and had both formal fair buildings such as the Women's Building and the Fine Arts Building as well as some Pay Streak attractions such as the circular Battle of Gettysburg Building. The east end of Yukon Avenue culminated in Nome Circle (plate 65A), which was surrounded by the Washington, Oregon, and Forestry buildings.

Seattle architects contributed building designs. For example, the firm of Willcox & Sayward designed the Firmin Michel Roast Beef Corporation Building; Bebb & Mendel the Washington State Building; Saunders & Lawton the Forestry, Women's, and Dairy buildings; and Ellsworth Storey the Hoo Hoo House. The buildings located away from the central court were designed by a variety of architects and ranged widely in style from Arts and Crafts, Spanish Mission, Pueblo Indian, and Japanese, to log cabin, and more traditional or utilitarian styles such as the Foundry (plate 71A). The most outrageous and wildly diverse buildings, of course, were on the Pay Streak, which did not have to conform to the standards of the rest of the fair. The Pay Streak had the Eskimo Village, a large, iceberg-shaped building; the Temple of Palmistry (plate 13), a pyramid-shaped building; and the House Upside Down and other unique structures.

One of the most spectacular buildings on the formal fairgrounds was the classical-style log Forestry Building designed by the firm of Saunders & Lawton and funded by the state of Washington (plate 67A). The fair promoters would have been aware of the log forestry building designed by A. E. Doyle for the 1905 Portland fair and probably wanted to outdo

their southern rival with this unusual and even bigger northwestern building. The curved front colonnade echoed the curved Manufactures Building that it was near. It was a massive building constructed of logs used in their natural state. The front columns of the building were made from 124 enormous logs from the Snohomish area, which weighed about thirty tons each. Edmond Meany, noting that the days of unlimited forests were passing, said of the Forestry Building, "The columned temple speaks of the forest in every one of its beautiful and dignified lines, while at the base of the columns cluster vines, mosses, and flowers. Like the American bison, these forest giants are disappearing all too rapidly. It may be that the next generation of men will find it impossible to reproduce such a building. All around the shores of Puget Sound the forests are falling and cities are rising in their places."[63] The A-Y-P mixed traditional eastern establishment themes, Beaux Arts landscape, and French Beaux Arts classical architecture with the natural beauty of the location and some eclectic Northwest and Asian themes. The central buildings and layout were of the usual formal exposition "White City" style, but the design also incorporated the natural landscape and Japanese design motifs. Structures farther out from the center reflected the Northwest in the use of materials and design methods. The Forestry Building combined indigenous northwest materials with a classical architectural vocabulary; the Arctic Brotherhood Building was a log cabin home (plate 14); and most unusual was the south entrance gate (and the railroad bridge that separated the north and south Pay Streak), which mixed Japanese and Native American designs as totem pole figures climbed up the Japanese-style gate structure (plate 15).

By April, most of buildings were completed and their exhibits installed or in the final stages of installation. There were three buildings for women—the American Women's League Building, the Washington State Women's Building (plate 64A), and the Young Women's Christian Association (YWCA) Building (plate 16)—which provided spaces for displays of women's accomplishments, lectures, social, dining, and rest areas. There were also buildings for men's groups, one of them the wonderfully named Hoo Hoo House located near the Forestry Building. It was built by the Hoo Hoo organization, a group of men who worked in various areas of the lumber industry. The Tudor Arts and Crafts building was designed by Seattle architect Ellsworth Storey to be a "haven of rest

for all lumbermen who visit the fair." Members also had the privilege of having their mail addressed to the building during the exposition.[64]

The state of Washington paid for the construction of the buildings that were meant to become permanent additions to the campus after the fair: the Fine Arts Building, the Machinery Pavilion, the Auditorium, and the Power Plant. Four counties provided their own buildings: King County (where Seattle is located), Yakima County, Chehalis County (now Grays Harbor County), and Spokane County (designed, oddly, in the Spanish mission style). Neighboring western states—California (plate 68A), Oregon (plate 66A), and Idaho—had buildings, and from the Southwest was the pueblo-style Utah Building. New York was the only eastern state to contribute a building: a replica of the William Henry Seward house in Auburn, New York, in honor of the statesman responsible for the purchase of the Alaska Territory. Japan and Canada had buildings on the main grounds and Sweden had a building along the Pay Streak. There were also cultural buildings such as the Fine Arts Building (plates 61A and 62A) and the Temple of Music (or Music Pavilion) (plate 60A), and buildings that were contributed by social or commercial groups such as the Arctic Brotherhood, Michigan State Society, Daughters of the American Revolution (DAR), and Baptist buildings. There were also sculptures contributed by various groups, such as Lorenzo Taft's statue of George Washington commissioned by the DAR (plate 44A) and the statue of Edvard Grieg, the Norwegian composer. In the south grounds were the stadium for athletic events, an exhibit area for livestock, a model farm, a live-game exhibition area, a military camp, and the U.S. Government Life Saving Station.

PHOTOGRAPHY BEFORE THE FAIR

Even before the exposition began, photography played an important role. As the fairgrounds took form, people were encouraged to visit and make photographs to send to out-of-state friends. A newspaper article on February 2, 1909, urged the public to participate in "Home Letter Day":

**Work Your Kodak and Send a Bunch of Pictures
Back Home
Tell the folks back east about the progress being made**
. . . Sunday Feb 7 will be "Home Letter Day." Sunday

you are commanded to write not less than five letters to someone outside the city, or state, telling them all about the exposition.

Let us make this suggestion:

"Seattle Feb. __ 1909
"My Dear _____
"What do you suppose? I have just paid our exposition another visit. When I handed the gateman 10 cents, he informed me that the price of admission would be raised to 25 cents after March 1. . . . This speaks well for the progress made in building the big fair.

The grounds are nearly complete and many of the big buildings are receiving exhibits. There is activity everywhere. The government buildings will be complete by April 1 and the exposition will be complete a month before the opening date.

Everything is now in readiness for the opening of the exposition. . . . There will be thousands of visitors in the city this year and you should pay the city a visit by all means."[65]

Although he still was running his photography studio in Nome, by 1908 Frank Nowell was spending much of his time in Seattle, where he opened a second photography studio. His success also allowed him to remodel his Nome studio and replace the tiny one-story structure with a much more substantial building. He was busy at work on the A-Y-P project throughout the year. As construction work went quickly and much of it was ahead of schedule, Nowell was kept busy documenting the progress of the evolving exposition landscape. By the winter and spring of 1909 the grounds of the exposition began to take shape as the buildings were completed. During the construction phase Nowell made several thousand 8" × 10" glass-plate negatives of the grounds, buildings, and various groundbreaking ceremonies (plate 11). His work concentrated more on the buildings themselves than on the construction, so he made fewer images of the workers.

Since the fair was to celebrate Alaska and its resources, many views of Alaska were needed. Nowell set out with his large view camera and glass plates on an extensive trip throughout Alaska and the Yukon. In southeast Alaska he stopped in Wrangell, Ketchikan, Sitka, Juneau (plate 8), Haines,

and Skagway. Then he went up into the Yukon to Dawson, and continued down the Yukon River, eventually ending up in Nome. (See, e.g., plate 9.) Local newspapers along the way reported on his trip. The Juneau newspaper, for example, as quoted in the *Seattle P-I*, noted that "he secured several hundred views of the city, its principal buildings, the waterfront and other points of interest." The Fairbanks newspaper said that Nowell was in Dawson and would be leaving for their city soon. He ended his trip in Nome and photographed his new studio building draped with a large banner advertising him as the official photographer of the A-Y-P. Shortly before leaving for Seattle, he made a five-part panorama of Nome taken from the harbor. The trip was a great success: The *Alaska-Yukon Magazine* reported, "Mr. Nowell made a trip through Alaska last season and secured more than a thousand splendid negatives of scenes depicting pretty nearly every phase of Alaskan life and from every easily accessible part of the territory."[66] Nowell sold copies of these photographs during the fair and they were probably also exhibited in the Alaska Building and in other areas.

He also collected glass-plate negatives from a number of Alaska photographers such as Case & Draper, Larss & Duclos, and Eric Hegg and brought them to Seattle to print and sell at the fair. The prints made from these negatives were stamped on front with "Photo Print by F.H. Nowell." He did not bother to remove the original photographer's caption. It was not unusual at that time for photographers to share their work or to copy one another's work. Nowell's advertisements now listed him as the "Official Photographer of the Alaska-Yukon-Pacific Exposition," giving his Seattle studio address, and his ad boasted, "We have a photograph of everything in the great North but the pole itself."[67]

During 1908 and early 1909, Nowell's photographs of the progress of the construction work on fair buildings appeared regularly in the local newspapers and even in far-away newspapers in Alaska and in the East. His photographs were used extensively by the exposition publicity department for promoting the fair in newspapers, magazines, and other venues. According to the *Alaska-Yukon Magazine*, the "department of publicity has been in operation for more than two years. . . . Photographs, cuts, plates, lantern slides, hangers, booklets, etc, are sent out by the hundreds of thousands."[68]

Nowell was working hard and had little time for a break as the need for photographs intensified.[69] In the months of April and May, as the opening of the fair was drawing close, the exposition's Department of Publicity paid $6,075.58 for "Photographs and Lantern Slides" and $5,475.66 for "Bird's Eye Views."[70] While some of this money may have gone to other photographers, it is likely that the lion's share of it went to Nowell. He even photographed the fair tickets, which were used as a full-page spread in the local newspaper on May 25, just before the opening of the fair (plate 17).

THE EXPOSITION OPENS

Noise and flags initiated opening day, June 1, 1909. The celebration began at noon Seattle time, when President William Taft in the White House pressed a telegraph key covered with Klondike gold nuggets, and the signal was transmitted across the United States to a gong on the A-Y-P grounds. At the same time, a Chinese bronze whistle on the gunboat *Politkofsky* gave a piercing blast, and then other vessels in the bay joined in. Businesses in town hoisted flags and blew whistles. When an enormous American flag was unfurled, releasing a shower of confetti and small flags, the crowd cheered and made a dash for the flags.[71] Later, there was a parade through downtown Seattle and about eighty thousand visitors attended the opening celebration in the exposition amphitheater, which overlooked Lake Washington and the Cascade Mountains. In addition to many prominent politicians and businessmen from the region, the opening event was attended by Rear-Admiral Hikojiro Ijichi of the Japanese Navy and Rear-Admiral Uriel Sebree of the U.S. Navy, both of whom were commanding fleets anchored in the Seattle harbor for the exposition. James J. Hill, president of the Great Northern Railroad, gave a welcoming speech similar to the one he had given at the 1905 Louis and Clark Exposition in Portland, extolling the possibilities of commercial prospects with the "Orient."[72]

The fair got off to a good start: The first week's attendance was 215,068, which was close to the population of Seattle.[73] There were four entrances—the Main Gate (plate 43A), the South Gate, and boat landings on Lake Union and Lake Washington (plate 72A). There were very few automobiles yet in Seattle so most people came to the fair by the streetcar, which had a terminus at the South Gate and also came within a block of the Main Gate. Visitors could take a steamboat to and from the boat landings, at intervals of fifteen minutes,

· **FIGURE II** ·
From A-Y-P photographic tour:
Frank H. Nowell's photography studio with banner
reading "Official Photographer, Alaska-Yukon-Pacific
Exposition," Nome, ca. October 1908.

PHOTO BY FRANK H. NOWELL. UNIVERSITY OF WASHINGTON LIBRARIES,
SPECIAL COLLECTIONS, NOWELL 6478.

for ten cents.[74] Out-of-town visitors mainly came by railroad; if they were coming from Tacoma, they could also take a seventy-seven-minute trip on the *Flyer* steamboat, for thirty-five cents one way.

Adults paid fifty cents and children twenty-five cents for admission to the fair. When visitors entered the Main Gate they could walk straight ahead between the Alaska Building and the U.S. Government Building and come out at the Alaska Monument in front of the Government Building (plates 45A and 46A). There in the Court of Honor, they would step into Olmsted's dramatic exposition landscape with the gleaming white federal buildings towering over them and the waterfalls and fountain in front flowing down to the view of the mountain (plate 55A). Or visitors could enter the Main Gate and go directly to the right, skipping the highbrow cultural offerings in favor of the excitement and color of the Pay Streak (plate 18), which ran south, down the western edge of the exposition grounds. Here the experience was a crush of people, noise, and variety. The architecture was built to entice, confound, and amaze—this was all about pleasure.

The fairgrounds were packed with possibilities; there was too much to see on one visit. Fortunately, the exposition offered reduced-fee passbooks for multiple visits. There were educational and edifying sights in the formal grounds of the exposition, although many exhibits had been recycled from previous fairs; as one critic put it, the Alaska exhibit was the only one that was not "moth-eaten."[75] That didn't stop people from enjoying the offerings, especially as most of them had not seen other world's fairs. The federal buildings had displays from most of the branches of the U.S. government. The Agriculture Building (plates 48A and 49A) boasted something new as it advertised the "first display of clams ever shown at an exposition."[76] In the U.S. Government Building, the Navy had models of ships and gunnery equipment and the U.S. Treasury had exhibits showing a mint and assay office for testing gold. Also, the U.S. Post Office exhibited stamps, mailing equipment, and mail transportation, featuring a model of an Alaskan mail carrier and his sled drawn by seven dogs. More sensational fare included a large collection of articles sent through the mail and ending up in the dead letter office, such as paintings, photographs, kitchen utensils, Indian relics, jewelry, and confiscated articles such as weapons, bombs, poisonous snakes and insects, and opium.[77] The Alaska Building (plate 47A) had a million-dollar pile of gold as its centerpiece, along with

displays of agricultural products (and pictures showing how huge they grew in the north), fishing, mining, and other industries. The Japanese presence was seen throughout the exposition, and it played the largest role of any of the Pacific Rim participants. Along with the Japanese Navy in the harbor on opening day, Japan had the only official government exhibit representing an Asian country. (Because of the harassment Chinese had endured at other world's fairs, the Chinese government refused to have an official exhibit.) The impressive Japanese exhibit was described as "putting all other foreigner exhibits combined in the shade."[78] The official Japanese Building (plate 59A) was a large complex with displays of culture and history; the exhibits ranged from full-size models of Samurai warriors dressed in armor to displays about silk production (see, e.g., plate 19). There was also the Nikko Pavilion just behind the Manufactures and Oregon buildings. And on the Pay Streak were the Streets of Tokio, where there was a Japanese tea garden, "a rice field in which Japanese coolies are seen at work setting out the rice plants" as well as "Japanese bazaars and Japanese babies and Japanese everything else to give an idea of the daily life of Nippon."[79]

The mining and agricultural industries were an important part of the building exhibits. The state and county buildings featured agricultural and commercial products from their regions. Displays of wheat, chili peppers, apples, olives, corn, and so on, filled the exhibit halls and were presented in inventive ways: California had a bear made of raisins, an elephant made of walnuts, and a huge lemon made of lemons (plate 20). As an important product of Asia, tea was featured in a number of places including the Formosa Tea Pavilion, where, the official daily program advertised, one could get "a Dainty Package of Sample Tea Given Free."[80]

Beyond the huge halls of the U.S. government buildings there were more exhibits. At the top of the Pay Streak, the Fine Arts Building had hundreds of paintings in its galleries (plate 63A) and one entire room devoted to displaying three volumes of Edward Curtis's North American Indian photographic portfolios, which a local newspaper reported as being considered the "greatest piece of bookmaking ever attempted."[81] The Swedish Building had a "miracle painting" of Christ, which was written up in the newspaper because it would supposedly become luminous in the dark with a shadow of the cross appearing in the glowing sky. The Washington State Educational Building had a Domestic Science

Kitchen and a Manual Training Department where Olympia High School students demonstrated cooking and construction activities. During the summer, the boys constructed the furnishings for three rooms—the shop, kitchen, and dining room —while the girls held cooking demonstrations and served banquets in the building (plate 21). Many social and commercial groups exhibited their particular specialties, and then there were the "big" displays. The Forestry Building had a giant pair of dice in the main hallway, captioned "the kind of dice we roll in Washington" (plate 22).[82] The "Big Stick," an immense piece of milled timber 156½ feet long, was outside the Forestry Building. California brought out the "largest book in the world," which weighed 555 pounds and was seven feet wide when opened (plate 23);[83] more "biggest" products could be found in other exhibit halls.

At night, the buildings and grounds were lit by an amazing display of electric lighting (plate 56A). Electricity was another wonder that had been exhibited at world's fairs since the 1890s. The lighting display was exciting enough to be reported in the newspaper, and visitors were dazzled: "By night the Exposition is a spectacle that has never been surpassed. The grounds and buildings are a blaze of light and the Cascades pouring down the central court,—a plunging rainbow, showing every color of the solar prism. The Geyser Basin, at the foot, is a lake of liquid-fire."[84]

ON THE PAY STREAK

The greatest excitement at the fair was found on the Pay Streak, the amusement area named after the term for the richest deposit of gold in a mining claim. It was a combination of ethnic, scientific, and historical oddities and wonders that ranged from the patriotic to the historical to the exotic and the thrilling. While the regular exposition grounds were well attended, photographs of the Pay Streak amusement area show that it was jammed with people. This may have been partially because the Pay Streak was a much more confined space (one long avenue running down the western side of the exposition grounds) and the formal grounds of the exposition were spread out across many acres, but it was also the simple draw of fun. This was the place on the exposition grounds where one didn't have to be proper or restrained in their enjoyment. Historians have observed that in this time period the social values of the Victorian era were beginning to change,

and amusement concessionaires were finding that "exuberant, daring, sensual, uninhibited and irreverent activities were more popular and more profitable." Popular rides such as the Ferris Wheel, L. A. Thompson's Scenic Railway (a mild type of rollercoaster), and the Tickler (a twisting slide) (plate 24) "threw patrons off balance and promoted shouting, screaming and other behavior consider unseemly in public. In short, the riotous noise and colorful exotic buildings of the Pay Streak created a liberated atmosphere conducive to breaking down inhibitions of the customers . . . [and] encouraged people to relax their sense of propriety."[85]

Many of the same concessions and amusements that had been at other expositions came to the A-Y-P. The Ferris Wheel had debuted at the Chicago Fair, which had also featured the two huge dioramas of American Civil War history, the fight between the *Monitor* and the *Merrimac* and the Battle of Gettysburg.[86] The Pay Streak offered a variety of vicarious experiences of other cultures, including those thought to be less civilized. Viewing other cultures through stereo cards and travel albums had become a popular method of experiencing the "delights of travel without its discomforts,"[87] particularly during the 1880s and 1890s, and these exhibits offered a similar safe but exotic experience. The Philippine Islands Igorrote exhibit of a working tribal village had been a hit at other world's fairs and was hugely popular here. Visitors could also see the Streets of San Marino ("the smallest republic in the world"), the Eskimo Village (plate 25), the Swedish Exhibit, and the Japanese Village and Streets of Tokio.[88] Despite the possibility of encountering harassment or racism, Seattle's small Chinese community wanted to be involved in the A-Y-P. The Chinese Village, financed and built by local businessman Ah King, made almost as much money as the government-sponsored Japanese Village.[89]

There were attractions that related to Alaska and the West, such as the Gold Camps of Alaska, the Alaska Theater of Sensations, the Klondyke Dance Hall and Saloon, and Charles Culps' California Indian Museum. Ezra Meeker's Pioneer Exhibit featured cabins, a restaurant, and Nez Perce Indians, as well as his famous oxen, Dave and Dandy, who became known worldwide when Meeker made a cross-country covered-wagon trip in 1906–8 to help promote the preservation of the Oregon Trail. Arthur Dexter's Wild West Show included Flathead Indians from Montana and famous bronco riders such as Jack Sunderson and Guy Holt (plate 26).[90]

Because no alcohol could be served on the University of Washington campus, the A-Y-P became the only dry world's fair. Even with drinking prohibited, there were a number of protests about the moral character of activities on the Pay Streak. The Klondyke Dance Hall (plate 27) was closed down as it "quickly degenerated into an altogether realistic model of an Alaskan dance hall at its worst."[91] Other protests from local clergy and the Women's Christian Temperance Union were less successful. A local clergyman and a group of civic leaders, including the governor, inspected Igorrote Village to determine if the men's loincloths were too revealing (plate 28). It was inevitable that there would be protests over the dances and the clothing of the performers on the Streets of Cairo, including Princess Lala, who performed Cleopatra's Dance of Death, La Belle Zamona and her Salome dance, and the belly dancer, Fatima.

Other exhibits on the Pay Streak were not so controversial, and there was always something novel, from Prince Albert the Educated Horse to the "Guess Your Weight" concession (plate 29) to the Captive Balloon, a large balloon tethered to the ground, which was equipped with telescopes that enabled people to view the fair from fifteen hundred feet in the air. No matter what their taste, there was something for everyone on the Pay Streak.

SPECIAL DAYS AND EVENTS

In addition to all the exhibits, the A-Y-P planners brought in a wide array of events and special days to attract visitors. The fair issued daily programs, and the newspapers publicized upcoming events. There were visits from prominent people, meetings held on the grounds, and lectures by all kinds of experts. President Taft came to attend the Arctic Brotherhood convention and be installed as Honorary Past Grand Arctic Chief in September. The brotherhood gave him a huge fur-lined parka, which he wore for a portrait. The group was not happy, however, when in his speech he affirmed his opposition to making Alaska a territorial government. Taft's political opponent, William Jennings Bryan, also came to speak and gathered a large crowd. Many conventions and meetings took place at the exposition. One of the most controversial was the eight-day meeting of the National American Woman Suffrage Association. The conference was attended by six hundred, and helped to bolster the Washington state suffragists' fight

for the vote, which was successful the following year. Their success encouraged voters in other western states to do the same, far ahead of the slower eastern establishment, which remained opposed to woman suffrage.

A popular way of attracting fairgoers was the use of "special days." Counties and towns across Washington state got their own days—Wenatchee, Bremerton, Chehalis County, Everett, Puyallup, Spokane County—as did other states, territories such as Hawaii (plate 30), and places in Canada such as Kamloops, Vancouver Island, and Prince Rupert. Seattle Day, held on September 6, brought in about 117,000 visitors, the largest paid attendance for any event ever held in Seattle.[92] There were special foreign days as well—Manila Day, German Day, Norway Day, Polish Day, and so on. The Japan Day celebration on September 4 was the largest and most elaborate of all the internationally themed days. Planning started over a year before the event and involved the local Seattle Japanese Chamber of Commerce and the Japanese Association. It included two parades, musical programs, ceremonial gift giving, a fireworks display and other events. Many local Japanese participated along with the large delegation of Japanese officials. The *Seattle Times* reported that the day was a proud moment for "the Japanese of two hemispheres." Historian Shelley Lee points out that Japan had a different experience at the A-Y-P than the other Asian countries. Because Japan was perceived as a modern country becoming like its white counterparts, it was given respect.[93]

While Japan Day had the backing of the official government and a large local community to make it successful, Seattle's Chinese did not have any help from the Chinese government but nevertheless wanted to do something spectacular for the China Day festivities. They borrowed a dragon from the Chinese community in Marysville, California, and held a dragon parade, something that few westerners had ever seen. The parade amazed the fairgoers, and the reception was uniformly positive. Goon Dip, the honorary Chinese counsel who had helped obtain the dragon, invited A-Y-P President J. E. Chilberg to ride in the front of the parade with him. Chilberg later recalled that he and Good Dip "became great and good friends until his passing, and to him I am indebted for most of my knowledge of Confucius and his teachings."[94]

There was a special day for practically every group, including: Octogenarian Day, Washington State Fourth Class Postmasters Day, Eastern Star Day, United Amateur Press

Association Day, Elks Day (plate 31), Handshaking Day, Raisin Day, International Beauty Day, Welsh Elsteddfod Day, Fish Day, International Language Day, Senate Committee on Irrigation Day, Esperanto Day, Newsboys Day, Washington Creamery Operators Day, Amateur Photography Day, Theatrical Mechanics Association Day, and Catholic Forester's Day, among many, many others. September 2 was Smith Day, an event certainly guaranteed to bring in a crowd. More than five thousand Smiths (and variations such as Schmidt, Smythe, etc.) were given purple badges with the words, "I am a Smith; Are You?" There was a parade for the Smiths, Ira Nadeau gave a talk on famous Smiths, and prizes were given out for the tallest, shortest, fattest, and thinnest Smith, and of course there were prizes for the prettiest baby Smiths. Vernon and Vincent Smith won in the best-looking Smith twins category; Jack Smith was the tallest Smith at 6 feet 2 inches; and Mrs. Harriet Smith, who gave her address as the King County Hospital, won the thinnest Smith category (plate 32).[95]

Music was also a big part of the fair. The Seattle Symphony Orchestra, Lacy's Dixieland Band, Liberati's Band from New York, the Journal Carriers Association of Portland Band, school and military bands, and many other musical groups came to perform over the summer. The fair organizers were also aware that sports were a big draw and included them in a major way. There were more organized sporting events than at any previous exposition, and the Ceremonies, Music, and Sports Committee spent more than any other department of the fair, accounting for about a third of the expenditures. Most of that money went toward prize money and special sporting events.[96] Special attention was paid to cultural and ethnic games: On Japan Day there was a judo demonstration and a jiu-jitsu tournament; on German Day there were gymnastic events put on by the local Turnverein (the Turners were German-American political and social groups that promoted sports, particularly gymnastics, as a way for training moral character); and on Scottish Caledonian Day there were Scottish track and field events. On Pacific Northwest Day Indian canoe racing was celebrated with a race between Washington and British Columbia tribes. Many years earlier, Indian canoe races had been a popular part of holiday celebrations in Seattle, and over ten thousand people attended the A-Y-P races that day. There also were lesser-known sports such as the tug-of-war tournament, races between animals, and games such as pie eating, greased-pole climbing and horseshoe pitching.[97]

Several special events took place outside the exposition. In July 1909, a group of mountaineers made the climb to the top of Mount Rainier as part of the A-Y-P celebration. The climb was led by Seattle photographer Asahel Curtis, and the group included Edmond Meany and a visiting mountaineer from Austria. The expedition was the largest ever to ascend the mountain, with seventy-nine people, the majority of them women. Sixty-two climbers made it successfully to the top on July 30, by way of a new route up the south side. While a number of the men gave out, all the women in the party completed the ascent. At the summit the climbers had a ceremony and unfurled an A-Y-P flag. Dr. Cora Smith Eaton ended the ceremony by attaching a silk pennant to the flagstaff with the words "Votes for Women," echoing the many messages that had been spread across the A-Y-P grounds on Suffrage Day a few weeks earlier.[98] Four members of the Army Signal Corps attempted to flash a message by a mirror back to their counterparts on the A-Y-P grounds, but the watchers at the exposition only caught a few letters because a heavy mist obscured the rest of the message.[99]

There was one grueling special event that the fairgoers could not watch, but they were there to cheer the finale: the transcontinental automobile race from New York City to Seattle, which started on the first day of the fair. In the early years of the twentieth century, the automobile was a novelty whose future was not necessarily assured in the mind of the public. The year before the fair there were fewer than a thousand automobiles in Washington State and Seattle had only recently raised the speed limit from six to twelve miles per hour.[100] The transcontinental race was sponsored by Robert Guggenheim, a member of a wealthy New York family, who was living in Seattle. The race in part was to promote the Good Roads movement, which advocated improved roads at a time when "roads" were generally local-area mud paths and there were no cross-country roads. A pathfinder car was sent out before the fair started to find a route for the race to follow. The contest began in front of the New York City Hall on June 1. The opening signal was transmitted from President Taft to the mayor, who fired a golden pistol to start the event. During the first half of the race, from New York to St. Louis, the racers were required to drive at legal speeds (ranging from fourteen to eighteen miles per hour) and only during the daylight. After St. Louis there were no regulations, because it was thought the roads were so bad that the racers couldn't speed anyway.[101]

A participant in one of the two Fords in the race wrote that they had to wear hip boots and rubber coats because of the mud and rain. Just outside Denver "both Ford cars got into the quicksand in the bed of Sand Creek. We were 30 feet from shore and working in water up to our waists . . . we might have been there yet, but with the aid of the roof of deserted pig pen . . . we got both cars out and made Denver."[102] Although the Midwest was difficult, the winning driver reported that the very worst road on the trip was the fifty-mile route over snow-covered Snoqualmie Pass just east of Seattle, which took nineteen hours to cross. The winning Ford no. 2 sped up Second Avenue in Seattle at fifteen miles per hour and entered the A-Y-P stadium to drive five laps to cross the finish line (plate 33). The two men in the Ford arrived covered in mud and dirt and on the point of collapse.[103] The trip had taken twenty-three days.

On August 13 and 14, the National Amateur Athletic Union Track and Field Championships were held, the largest sporting event of the summer. The fair organizers had worked hard to convince the organization to hold the AAU meet at the exposition. This was the first real East–West track meet ever held, since the western teams were never able to send full teams to the meets, which generally took place in the eastern states. To the shock of everyone, the Seattle Athletic Club, which had never placed in the national championships, ran away with the victory, soundly beating the eastern athletes.[104] The success of the Seattle athletes in this sporting event accomplished what the fair organizers wanted—to raise the status of the city in the national scene.

PHOTOGRAPHING THE A-Y-P

Nowell photographed most of the aspects of the fair, from the construction through the events of the summer of 1909. He concentrated on photographing the buildings, grounds (plate 42), exhibits, and formal portraits of groups and clubs at the exposition. He also recorded the interiors of the buildings, showing the variety of exhibits. (He must have felt right at home when photographing the U.S. Post Office exhibit of a dogsled team for mail delivery, having seen many of them in front of his own studio next to the post office in Nome.) In November 1908 he was both the official photographer and a participant when the Arctic Brotherhood held a ceremony to lay the first log for the Arctic Brotherhood Building (plate 35).

Nowell was a member of the building committee. Along with the University Regents and members of the brotherhood, he also participated in the formal dedication ceremony on June 1, 1909.[105]

He often photographed from a ladder to make views from above the crowd, using a very tall tripod to hold the camera, and some of his work was done from the tops of buildings. (See, e.g., plate 36.) His photographs are formal and deliberate; they were meant to show off the buildings and to showcase the exhibits inside them. He used triangular side views to give a sense of the large-scale grandeur of the buildings and elegant sweeping curves to define the framing such as his interiors of the Manufactures (plate 34) and Agriculture buildings under construction.

Some of his early construction photographs and the postcards made from them were issued simply with "copyright by the Alaska-Yukon-Pacific Exposition" without his name on them. (See, e.g., plate 37.) Later he evolved an "official" A-Y-P signature and numbering system for his negatives, starting out with a simple "F. H. Nowell" plus a number and ending up with a fancy label (containing his name and "official photographer Alaska-Yukon-Pacific Exposition") and numbers prefaced by an X (X1397) for the exposition negatives.

Nowell's photographs were used for publicity and in many other ways. Many of the exhibits and buildings had souvenir guidebooks for the fair visitors, and prints were also sold as individual souvenirs. The frenzy for photographs created more work than one person or studio could do, so Nowell turned over parts of the workload to other photographers who either worked for him or had concessions on the grounds: "There were studio men who specialized in portraits of dignitaries, others who covered parades and special events, some who were adept at trick photography and weight guessing, and those who strolled the vast Exposition grounds making more-or-less candid views of whatever presented itself."[106]

Nowell would have needed a large staff to process and print his negatives. The picture of the Official Photography Building (plate 38) shows a group of about sixteen photographers or darkroom workers with a variety of cameras, including one on a very tall tripod that had to be used with a ladder, and a large Century camera (which was commonly used in a studio for portraiture) sitting on the ground, having been brought outside to be included in the photograph.

· **FIGURE 12** ·
Dirigible balloon, Alaska-Yukon-Pacific
Exposition, in flight over the
military camp, 1909.
PHOTO BY ORVILLE J. ROGNON.
UNIVERSITY OF WASHINGTON LIBRARIES,
SPECIAL COLLECTIONS, UWI8365.

One person who worked for Nowell during the fair, at least in the later days of the summer, was someone he had met years before in Alaska—Orville Rognon. After teaching in Alaska for some time, by 1906 Rognon had moved to Seattle, where he tried various other occupations before turning to photography in 1908. While he is listed in the 1909 city directory as working for Webster & Stevens, Rognon probably stopped working for them when he started to work for Nowell at the A-Y-P, because the next year he was listed as an independent photographer. The Rognon photographs that remain today are mostly of physical activities and the events that took place on the outer edge of the fair—the sports, military, stock shows, and dirigible-launching events—and of visiting officials. (Nowell did not photograph active events

such as sports.) Rognon's work was never signed, although it sometimes appeared with Nowell's stamp. He used a numbering system that was different from Nowell's—an R and a number (R-145); he also worked in 5" × 7" rather than 8" × 10". Rognon was not as good a photographer as Nowell and his photographs are generally easy to distinguish from Nowell's. Rognon's photographs lack the crispness and sharpness of Nowell's work and are not as well composed. The two men clearly were friends, however, because after the fair Rognon became Nowell's studio partner for two years.

One of the photographers working for Nowell would have specialized in portraiture. (The photograph of the Official Photographer Building, plate 38, shows a large portrait camera.) Portraits were needed even before the fair opened.

Employees at the exposition were required to have passes with their pictures on them, which cost $2.00, and also the exposition sold coupon books until the opening day that required a photograph on the cover as identification. By May 11 more than five hundred portraits for coupon books had been made.[107] The secretary's report on the exposition listed $1,400 in "Sundry Pre-Exposition Receipts" for photo passes and a total of $6076.50 in earnings by the end of the fair,[108] so the day-to-day commercial portrait business was a profitable enterprise at the exposition.

Edward Curtis, the well-known photographer of American Indians, had a "rather grand portrait studio" at the A-Y-P, for more formal portraits, as well as his exhibit of volumes from his North American Indian project showing in the Fine Arts building.[109] His A-Y-P studio was managed by Ella McBride, who later left the Curtis studio to open her own. A. J. Park had the Electric Studio, located next to the Official Photographer Building, where he sold photographic postcards. Mace Charleston, who had another studio at an amusement park and one downtown, had a studio on the Pay Streak, which produced instant souvenir photos: "These were post card quick finish pictures, six for fifty cents, while you wait."[110] Robert Tallaferro Jones, who was working for Mace Charleston, went up in the "captive balloon" (a hot air balloon anchored to the ground with a long cable) with his hand camera and took what was believed to be the first balloon/aerial photograph of Seattle: "The balloon was let out on a steel cable six hundred feet. The basket that the passengers stood in would hold two to four people. . . . Later I enlarged this picture to 8 by 10 inches. I cut out the top dreary clouds and printed in some leafy clouds that I had made over the Puget Sound. . . . Through the official photographer we made and sold hundreds of pictures on a percentage basis of one dollar each."[111]

Because the photographic technology of the time made it difficult to record both landscape and clouds, it was quite common to print clouds into photographs to make the pictures look better, as Jones describes. Nowell, however, took the "printing-in" practice to a higher level when he created a dramatic view down Rainier Vista from the top of the U.S. Government Building. This was the vista that the Olmsted Brothers created as the exposition centerpiece. It was the major axis that ran from the central courtyard of the large classical buildings flanking the Cascades and Geyser Basin, stepping downhill to the natural landscape at the edge of the fair and then out to Mount Rainier. The Alaska Monument in front of the Government Building is in the foreground as the focal point for the civilized, cultural landscape, and an enormous mountain dominates the background as the symbol for the natural world. This photograph, however, while it provided a stunning setting for the exposition, was actually made from two negatives printed together. While the view of Mount Rainier is quite spectacular, the mountain would have to be many miles closer to Seattle to appear so large. Nowell made the photograph of the grounds, which was used in many A-Y-P publications, and then printed in another negative of Mount Rainier in the background to achieve the huge mountain looming over the fairgrounds (plate 39). Both versions of his photograph were used in the guidebooks, made into large postcards, and also sold as large 11" × 14" prints during the fair.

Nowell's photograph numbering system goes up to at least X4691 (made in September 1909), implying that he made close to five thousand negatives, from construction through the days of the fair, although it is clear that at least a small number of photographs using his numbers are actually by others. Some are by Rognon (those often have Rognon's R numbers on them also), and X4000, an aerial view of the grounds enlarged to 11" × 14", is probably a photograph by Robert Tallaferro Jones printed under Nowell's official stamp. Some of the other numbered negatives may have been made by assistants working for Nowell, but the style and consistency of the photographs indicates that he made the majority of the photographs with his name on them.[112]

Nowell also made money from the amateur photographers who came to the fair. Since Kodak had introduced the mass-market amateur camera just a few years earlier in 1900, photography, or "Kodaking," had become quite popular. The exposition promoters encouraged people to bring their cameras and touted the A-Y-P's "different," more liberal approach, allowing fairgoers to use their own cameras for free as long as they were not larger than 6" × 8", which would make a photograph about the size of a postcard. A newspaper article in March 1908 described the camera rules at other expositions and discussed how the A-Y-P was going to be more inviting to "Kodakers":

"Come to the Alaska-Yukon-Pacific Exposition in 1909 and bring your camera."

That is the invitation extended by the management of the 1909 fair to the people of this country and especially to the devotees of photographic art. Again the Alaska-Yukon-Pacific Exposition is departing from the policies of former expositions and doing something different.

The division of concessions . . . will permit under the contract of the official photographer, all kodaks and cameras not more than 6x8 inches in size to be taken on the grounds and visitors will be allowed to take all the pictures they desire of the buildings, exhibits and other features.[113]

The camera owner had to obtain a pass from the manager of concessions that permitted photography on the grounds. Beyond the size of the camera, there was only one restriction —amateur photographers could not bring in a tripod. They could go to F. H. Nowell's Official Photographer Building on the Pay Streak and buy supplies, and then have their photographs developed, printed, and mounted. On July 23, 1909, one fairgoer, a woman from Port Angeles, Washington, sent a friend a postcard with a picture of the A-Y-P central courtyard: "Dear Mrs. Williston. I am safely at home and am just commencing to feel rested. This is one of my pictures—had splendid success—only 2 out of 54 spoiled. I shall never forget my Seattle Trip and I thank you so much for helping to make it so pleasant. With love, Ruth."[114]

During this era, photographic postcards were a hugely popular medium for communication with friends and family, and a great source of revenue for photographers. Many photographers, both commercial and amateur, made their photographs into postcards. At the A-Y-P, postcards were widely distributed—used by the exposition committee to promote the fair, given out at exhibits, and sold as souvenirs in various places throughout the grounds. Postcards with real photographs on them and also postcards printed in both color and black and white were widely distributed. Nowell's photographs were used both as photographic and as print postcards. In 1908, before the exposition opened, photographic postcards using Nowell's photographs were issued with the caption "AYPE Company." Later during the exposition, "official" printed postcards of his photographs were extensively published by both Robert Reid (who also published souvenir books using Nowell's photographs) and by the Portland

Postcard Company (PPC). The two publishers even used some of the same views—Reid's published view of Nowell's photograph of the Life Saving Station (plate 40) was printed in black and white, while the PPC issued the same view but with color printed over the image. The PPC, which issued the biggest selection of Nowell's images, used the official A-Y-P logo on the front of the cards and numbered them using X in front of the number (X1417), the same numbering system that Nowell used for his exposition photographs. The PPC also published Nowell's portraits of Alaskan natives and many other Alaskan scenes for sale at the fair.

Since the camera permit allowed a negative that was the size of a postcard, a number of local photographers took advantage of the craze and made photographic postcards for public consumption. These included Oakes Photo Company, Otto Goetze, William Romans, O. T. Frasch, and A. C. Warner. (B. B. Dobbs, who had been a photographer in Nome, also came to the exposition to make postcard views.) The postcard business proved to be somewhat contentious. In October 1908, local photographers complained that they were refused admittance with their cameras and that an out-of-town company (Portland Postcard) was going to get all the business. The manager of a local photography company wrote, "I have offers from the publishers of eastern magazines for views taken of the buildings and grounds of the A-Y-P, and could I secure these views they would greatly help in advertising the fair. As it now stands, this concession has been granted to a firm outside of Seattle, and every effort is being made to prevent local firms doing any business in this line."[115] Concession officials issued a statement saying that no one would be refused and that all cameras within the size limits were allowed onto the grounds upon securing a permit.

Postcard sales were serious business. Just as paparazzi today might fight to get an exclusive photograph of a celebrity, the purveyors of postcards were trying to protect their rights to make some money from the fair. In December 1908, the Portland Postcard Company complained that they were being cheated out of their exclusive concession for the manufacture of souvenir postcards made from exposition photographs. They claimed that the A-Y-P Exposition Company was supposed to turn over pictures (mostly made by Nowell) of the new buildings under construction for their exclusive use on postcards but that "pictures of the permanent buildings and certain other photographs have gotten into the hands

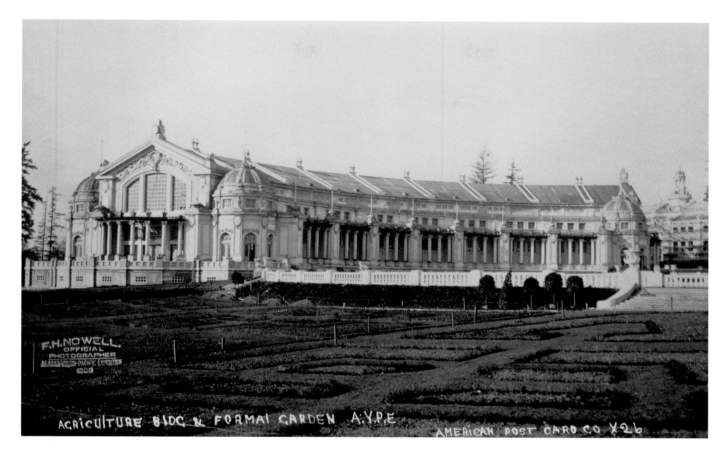

· **FIGURE 13** ·
Agriculture Building photo by Frank H.
Nowell issued as a post card under
O. T. Frasch's American Post Card
Company name.
COURTESY OF DAVID CHAPMAN.

of rival concerns and that these companies are planning to flood the market with cheaper souvenir cards than the concessionaires can issue."[116] The exposition company conceded that some photographs did get to rival companies before the Portland Postcard Company received them. A photographer who might illustrate the validity of the complaint was O. T. Frasch, who issued Nowell's construction photographs as photographic postcards and just added his name or American Post Card Co. (and sometimes even left Nowell's stamp visible on the photograph).

Where Nowell's photographs were formal and often taken from a distance, the postcard photographers tended to take more views of people and events, getting close into the action

with the fairgoers. Oakes, for example, made many candid views among the crowds of visitors on the grounds, capturing more of the experience of being among the people but less of the scale and grandeur of the exposition. Postcards could be amusing and whimsical: At A. J. Park's Electric Studio or at Mace Charleston's studio, fair visitors could have postcard portraits made showing them flying over the exposition in an airship or driving to it in an automobile, both methods of transportation being novelties during this era. The importance of postcards to the fair was made evident in May 1909, just before the exposition opened, when Seattle declared a "post card week," as a "final manifestation of the city spirit in aiding the exploitation department of the Alaska-Yukon-Pacific

· **FIGURE 14** ·
Postcard of exposition visitors
photographed riding in a fake A-Y-P airship
at Mace Charleston's studio
on the Pay Streak, 1909.
UNIVERSITY OF WASHINGTON LIBRARIES,
SPECIAL COLLECTIONS, UW2813IZ.

Exposition to give the fair all possible publicity previous to its opening."[117] Stores in the city participated in a contest to make the best window display of the official exposition postcards, and the public was encouraged to make "postal-card buying a public movement." The public's desire for postcards made it a lucrative business for both the official postcard concession and the other photographers. From the number of photographers who got in on the action, shutters were clicking all over the exposition grounds in a new rush for Klondike gold.

THE FAIR COMES TO AN END

The summer was a whirl of possibilities. People could stroll the grounds and visit the educational exhibits, view classical art in the Fine Arts building or Edward Curtis' photographs of Indians, attend lectures, rest in the women's building (if they were female), ride the Scenic Railway across the grounds, attend a sporting event, watch a cattle judging, go up in a balloon, eat at a myriad of restaurants, find amusements on the Pay Streak (plate 41), and then perhaps just sit on the grounds and view the beautiful lake and mountain scenery. After 138 glorious days, the fair closed on October 16, 1909. The farewell

parade made its way to the amphitheater, where everyone sang "Auld Lang Syne." By the end of the evening the fair was over. President Chilberg gave the signal and the lights went out. Almost four million visitors had come through the turnstiles, making the fair a financial success and leaving behind a small profit for the stockholders. That surplus was donated to the Antituberculosis League and the Seamen's Institute.[118]

John Barrett, Director of the Bureau of American Republics, expressed the hope of the fair organizers when he said, "The real exposition is the City of Seattle, that wonder city which has sprung up while we were asleep. The A.Y.P.E. is doing more than anything that ever happened to gain recognition for this state by members of Congress. . . . You have had scores of prominent visitors to the fair who never understood the size and possibilities of this city and the surrounding territories."[119] Whether this was indeed the legacy of the fair would have to be debated by scholars in the years to come, but at the time the exposition made the citizens of Seattle feel that their city had come of age.

From the beginning, four A-Y-P buildings were intended to be permanent structures on the University of Washington campus: the Auditorium, the Fine Arts Building, the Machinery Building, and the Power Plant. These buildings were constructed with steel frames and brick cladding rather than the wood frames and lath and plaster exteriors found on most of the buildings intended as temporary structures. However, the lease of the grounds for the A-Y-P specified that the university could claim as many of the temporary buildings as it might want. At the end of the fair, the university retained over twenty additional buildings, some used for only a few years while others lasted longer. Notable among these were the Women's Building; the Foundry; Hoo Hoo House, which became the faculty club; and the Forestry Building, which was used for the Washington State Museum (eventually the Burke Museum) and was torn down in 1931 because of rot and insect damage. Of the "permanent" buildings, the Auditorium became Meany Hall and was used for concerts and theatrical productions until 1965, when it had to be torn down following an earthquake; the Fine Arts Building became the Chemistry Building and is now Architecture Hall; the Machinery Building became the Engineering Building and was demolished in the 1950s for the present Mechanical Engineering Building; and the Power Plant has been substantially changed and expanded over the years.[120]

After the fair, the Seattle Parks Department continued to maintain the grounds and leased the property as part of the parks system. The 1912 annual Parks Department report stated, "While a great many of the Exposition buildings have been removed the beautiful landscape work was not impaired to any appreciable degree, and the tract is a valuable adjunct to the park system of the city."[121] By 1915, the maintenance of the remaining exposition property was turned over to the university. The gift of buildings from the A-Y-P was a mixed blessing. While the exposition landscaping meant that the university could make better use of the spaces on its grounds, many of the remaining structures were of questionable value. Henry Suzzallo, who became president of the university in 1915, was burdened with trying to keep the campus running with many buildings that were flimsy and deteriorating. Although such buildings were in need of repair and replacement, their existence was an excuse for the legislature to refuse funding to upgrade the campus facilities.[122]

Two of the A-Y-P buildings still remain in reasonably intact form. The Fine Arts Building (now Architecture Hall) has recently been renovated. The Women's Building was used as a campus women's center until it was taken over by the Mining Station in 1916. Despite attempts to win back the building for use as a women's center, it continued to be used for other purposes. Finally, in 1983, the building became the Imogen Cunningham Hall and the home for the University Women's Information Center. There are remnants of several other buildings, including the Foundry, which has been incorporated into the Engineering Annex. Some of the statues from the exposition remain on the campus—the most prominent being the statue of George Washington, which stands on the western edge of the campus looking out at the Olympic Mountains. The Olmsted landscape design created for the fair became the basis of the University of Washington campus plan, and Rainier Vista is the most visible remnant of the exposition—the view of Mount Rainier is one of the highlights of the campus. These remaining traces of the fair, along with Frank Nowell's photographs, have served as the inspiration for a modern rephotographic project led by John Stamets of the university's Department of Architecture. Stamets and students in his architectural photography class carefully researched the sites of Nowell's 1909 photographs and produced repeat photographs of the same sites, many of which are included in this book.

· **FIGURE 15** ·
Demolition of the A-Y-P Auditorium
(Meany Hall), August 1965.
UNIVERSITY OF WASHINGTON LIBRARIES,
SPECIAL COLLECTIONS, UW6805.

FRANK H. NOWELL AFTER THE FAIR

The fair was a great success for Nowell and certainly the high point of his photographic career. After the exposition, he continued his commercial photography, operating a studio in the Central Building in Seattle as well as his Nome studio. His advertisement in the 1910 Seattle city directory listed both of his studio locations. It also mentions that he was the official photographer of the A-Y-P and that he was "Awarded 3 Grand Prizes A.Y.P. Exposition." He marketed to the continuing interest in Alaska and Eskimos by listing them as specialties of his studio. In 1911 and 1912, he was in a partnership with Orville Rognon. While Nowell had an assistant working for him in the Nome studio,[123] Rognon was the only partner he ever had; their photographs were signed "Nowell & Rognon." It is interesting to note, however, that photographs exist with Rognon's R numbers but printed with Nowell's studio stamp (rather than Nowell & Rognon) on them, and there were also photographs just signed "F.H. Nowell" during that time.[124] Other than the photographs that were signed with both men's names, it appears that Rognon never signed his work. Rognon

left Seattle by 1913 for Vancouver, BC, where he worked for the Canadian Photo Company for several years.

Nowell's photographic assignments included documenting the launching of a ship, the construction of the Smith Tower (then the tallest building west of the Mississippi River), mining operations around King County, and a wide variety of other commercial subjects. In 1914, he produced a spectacular nine-part 360-degree panorama of Seattle made from the top of the Hoge Building. He closed his studio in Nome after 1912, and by 1917 he had moved to a new location at 1212 4th Avenue in Seattle, where he stayed until the building was torn down for the construction of the Olympic Hotel. He then moved to the White-Henry-Stuart Building at 4th and University.

Nowell remained active in various Alaska-related groups, and he was included in a commemorative album of portraits of Arctic Club members made by the Curtis Studio in 1916 or 1917. The celebration of the twenty-fifth anniversary of the Klondike Gold Rush on July 17, 1922, would certainly have been a high mark for Nowell. As someone who loved a good

· FIGURE 16 ·
Frank H. Nowell's studio at
1212 4th Ave, Seattle, ca. 1918.
PHOTO BY FRANK H. NOWELL.
UNIVERSITY OF WASHINGTON LIBRARIES,
SPECIAL COLLECTIONS, NOWELL 26393.

· **FIGURE 17** ·
Frank H. Nowell, ca. 1917.
PHOTO BY CURTIS STUDIO.
UNIVERSITY OF WASHINGTON LIBRARIES,
SPECIAL COLLECTIONS, UW28010Z.

time, he was undoubtedly in the thick of the celebration, enjoying memories with his Alaskan friends. Seattle held a huge celebration with a two-mile-long parade, fireworks, and a gathering in a party space decorated like a Klondike dance hall with all kinds of Alaskan curios. There was even an article about Nowell and his father in the newspaper on the day before the celebration. (Thomas Nowell had died in 1914.) The article focused mainly on Frank's activities during the Gold Rush and mentioned that he was a member of the Yukon Order of Pioneers."[125] This celebration was also probably a good occasion for Nowell to sell more of his Alaska and A-Y-P photographs. The event brought in over a million dollars to help fund the construction of the Olympic Hotel. Nowell's Alaska experience was also recalled in about 1923 or 1924 when he was contacted by the producers of Charlie Chaplin's film *The Gold Rush,* who wanted photographs of Alaskan scenes. His daughter related, "It pleased him so much . . . to have the producers come to him for photographs of Alaska cabins and snowdrifts and people from which they could build authentic sets."[126]

While Nowell continued to work as a commercial photographer until at least 1928, he may have been getting bored or just needed some variety. By 1925, he was also running the state-wide distribution for the Castolene Sales Company. By the time he was sixty-five, Nowell had closed the studio. He may have gotten tired of photography, or found too much competition. In 1931 the city directory listed him as the president of the All Oil Lubricating Company. He later was manager and purchasing agent for his daughter's store, the Dorothy Design Company.

Nowell lost his wife in 1937. Not long afterwards, he retired to live with his daughter at Crystal Lake near Seattle. He loved to fish and often took his nephews out with him in his retirement years. One of his nephews remembered him as a "great fisherman, a quiet man, gentle and meticulous."[127] "My father never seemed to have a great incentive to be rich or famous," recalled his daughter, Dorothy, "Of course the family always had money and father was inclined to be rather disinterested about it all, having a good 'fun sense' and appreciating all of life's interesting details. He was an enthusiastic fisherman and loved the outdoors with all its beauty and utility."[128] Nowell died in Seattle on October 19, 1950, at the age of eighty-six. His obituaries, as well as an article about him in the *Seattle 92 Elkogram* the year before his death, related his

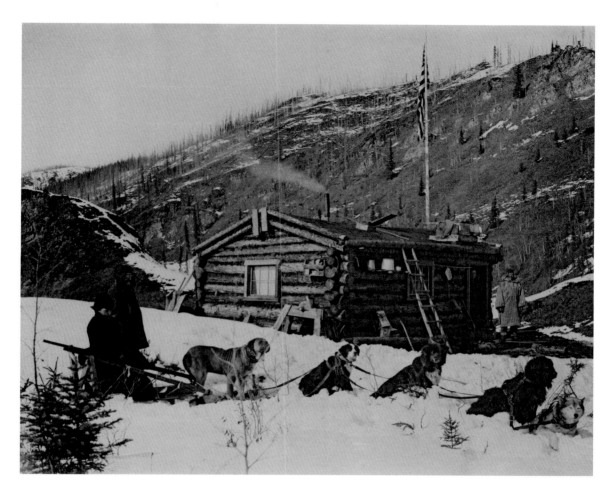

· **FIGURE 18** ·
"The Dividing Line between Canada and Alaska"
(log cabin at the Alaska-Canada border), 1906.
PHOTO BY FRANK H. NOWELL. UNIVERSITY OF WASHINGTON
LIBRARIES, SPECIAL COLLECTIONS, NOW271.

experiences in Alaska and mentioned his Seattle photography studio but did not refer to his work at the Alaska-Yukon-Pacific Exposition.

Evidence of the fair was obscured, lost, or forgotten as time passed. One person, however, never forgot his experience at the A-Y-P. Al Rochester was fourteen years old when he got a job on the Pay Streak. The concession he was working at went broke within a week, but he kept his employee pass and returned every day to the fairgrounds. These visits

made a lasting impression, and in 1955, when Rochester was a Seattle councilman, he suggested the idea of another world's fair. The response was not enthusiastic but he persisted, and in 1962 Seattle hosted the Century 21 World's Fair, another memorable look at the future.[129] The A-Y-P looked to the future rather than celebrate the past: "The Alaska-Yukon-Pacific will be anticipative. It is not to be the day that was, but for the day that is to be."[130] Over fifty years later the A-Y-P served as the inspiration for another world's fair, but it had faded from

· **FIGURE 19** ·
Frank Nowell, Official Photographer,
Alaska-Yukon-Pacific Exposition,
and his camera reflected in a gazing ball
in the formal gardens of the exposition,
May 1909.
PHOTO BY FRANK H. NOWELL. UNIVERSITY OF WASHINGTON
LIBRARIES, SPECIAL COLLECTIONS, NOWELL X1144.

most people's memories just as Bagley had predicted: "Yet well we know that all such memories must go the road of the unremembered past."

Frank Nowell left little behind about his life and career. A modest man, he probably did not think that his work would live on for over a hundred years. Examples of his Alaskan photographs survive in a number of archival collections, but the majority of his work is gone. Fortunately, many years after the exposition, some of the participants gave the University of Washington Libraries photographs they collected during the

fair. As a result, the University of Washington Libraries holds the largest collection of original Nowell A-Y-P photographs —about a fourth or fifth of the total he made during 1908 and 1909. Nowell's talent and appreciation of "all of life's interesting details" left us a legacy that gives us a window to a past we could otherwise only imagine. At the centennial of the Alaska-Yukon-Pacific Exposition, his photographs remain to help put our history in perspective and to connect us to the unique events that they documented on the University of Washington campus that summer a hundred years ago.

· NOTES ·

1. Clarence B. Bagley, *History of Seattle from the Earliest Settlement to the Present Time* (3 vols.; Chicago: S. J. Clarke, 1916), 2:529.

2. Lisa Mighetto and Marsha Babcock Montgomery, *Hard Drive to the Klondike: Promoting Seattle during the Gold Rush,* http://www.nps.gov/archive/klse/hrs/hrs.htm. Also available in print version (Seattle: Northwest Interpretive Center in association with University of Washington Press, 2002).

3. Kathryn Morse, "The Klondike Gold Rush," Center for the Study of the Pacific Northwest, http://www.washington.edu/uwired/outreach/cspn/Website/Resources/Curriculum/Klondike/Klondike%20Main.html

4. Mighetto and Montgomery, *Hard Drive to the Klondike.*

5. *Seattle City Directory* (Seattle: Polk's Seattle Directory Co., 1905).

6. Julie K. Rose, "A History of the Fair," The World's Columbian Exposition: Idea, Experience, Aftermath, http://xroads.virginia.edu/~MA96/WCE/history.html

7. Bagley, *History of Seattle,* 2:523.

8. Ibid., 524.

9. Alaska-Yukon-Pacific Exposition, *The Exposition Beautiful* (Seattle, 1909), 1.

10. *The Alaska-Yukon-Pacific Exposition Illustrated* (Seattle: Robert A. Reid, 1909), 2.

11. Alaska-Yukon-Pacific Exposition, *Alaska-Yukon-Pacific General History* (Seattle, 1909).

12. George Frykman, "The Alaska-Yukon-Pacific Exposition," *Pacific Northwest Quarterly* 53, no. 3 (July 1962): 90.

13. Edmond S. Meany, "What It All Means: The Great West, Its History, and the Yukon Exposition," History and Literature of the Pacific Northwest, http://www.washington.edu/uwired/outreach/cspn/Website/Hist%20n%20Lit/Part%20Four/Texts/Meany%20Means.html

14. Frank Nowell, "Narrative," unpublished paper, possibly for the Sons of the Pioneers, n.d., given to the author by Anna Frohlich.

15. "Alaskan Pioneer Dies in Seattle," *Seattle Sun,* January 6, 1914.

16. John Eldridge Frost, "The Nowells in York," unpublished paper, n.d., 96, given to the author by Anna Frohlich.

17. Willis Nowell, unpublished and undated memoir, Nowell Family Papers, 1883–1950, Alaska State Library, Alaska Historical Collections.

18. Frank Nowell, "Narrative."

19. Smithsonian Museum, *Report of the United States National Museum* (Washington, DC: U.S. Government Printing Office, 1889), 463.

20. R. N. DeArmond, *The Founding of Juneau* (Juneau, AK: Gastineau Channel Centennial Association, 1980), 182–83.

21. *Daily Alaska Dispatch,* October 30, 1907.

22. David and Brenda Stone, *Hard Rock Gold: The Story of the Great Mines That Were the Heartbeat of Juneau* (Juneau, AK: Juneau Centennial Committee, 1980), 88.

23. David Kiffer, "Cruising to Alaska, circa 1887," SitNews Stories in the News, http://www.sitnews.us/Kiffer/CruisingAK/080707_alaska.html

24. *Alaska Free Press,* April 23, 1887.

25. Ibid., June 4 and July 16, 1887.

26. Juneau-Douglas City Museum, Digital Bob, NGC_bob_1980-06-16_589, July 31, 1890, http://www.juneau.org/parkrec/museum/forms/digitalbob/readarticle.php?UID=540&newxtkey=nowell

27. Ibid., October 31, 1889.

28. Donald Deschner, "Frank H. Nowell," *Alaska Review* (Fall–Winter 1968–69): 194.

29. "Historical Sketch Interesting Events Recalled by the Visit Here of Frank Nowell, Formerly of the Nowell Mining Company," *Fairbanks Sunday Times,* September 13, 1908.

30. Deschner, "Frank H. Nowell," 193.

31. G.M. Ford, *A Blind Eye* (New York: William Morrow, 2003), 224.

32. Horace F. Clark, *Miner's Manual United States, Alaska, the Klondike* (Chicago: Callahan & Co., 1898), 252.

33. "Nowell Family Helped to Make History in Klondike Vastness," *Seattle Daily Times,* July 16, 1922.

34. Clark, *Miner's Manual,* 252.

35. Thomas Nowell quoting Frank Nowell in letter to E.E. Huxley, November 5, 1898, in MS 31 Nowell Gold Mining Company, Alaska State Library, Alaska Historical Collections.

36. Thomas Nowell to Frank Nowell, December 5, 1898, in ibid.

37. Undoubtedly the Archibald Burns from whom Nowell purchased his hauling company in Juneau.

38. Frank B. Norris, "The Chilkoot Trail Tramways," ed. Karl Burcke, in *Study Tour of the Yukon and Alaska* (Ottawa: Society for Industrial Archaeology, 1990), 6.

39. Roy Minter, *The White Pass: Gateway to the Klondike* (Toronto: McClelland and Stewart, 1987), 168.

40. Steven C. Levi, *Boom and Bust in the Alaska Gold Fields: A Multicultural Adventure* (Westport, CT: Praeger, 2008), 90.

41. "The Butler Brothers Gold Rush: The Nome Album 1900–1901," University of Alaska Fairbanks, http://photolab.elmer.uaf.edu/gallery/photos/19640033/butler/index.html

42. Terrence Cole, *Nome, City of the Golden Beaches* (Alaska Geographic Society 11, no. 1, 1984), 50.

43. Edward Harrison, *Nome and the Seward Peninsula: History, Description, Biographies and Stories* (Seattle: Harrison, 1905), 58.

44. Cole, *Nome, City of the Golden Beaches,* 57.

45. He probably moved his family to a boardinghouse to save money and so that they would be able to join him quickly if he decided to stay in Nome.

46. Henry J. Woodside, "Dawson As It Is," *Canadian Magazine of Politics, Science, Art and Literature* 18 (May–October 1901): 411.

47. T. G. Wilson, "The Eskimos' First Christmas Tree," Alaska's Gold, http://www.library.state.ak.us/goldrush/ARCHIVES/manu1/004_8.htm

48. Ella Higginson, *Alaska, the Great Country* (New York: Macmillan, 1923), 528.

49. "The Story of a Whale Hunt," *Alaska Journal* 11, no. 1 (1981): 134–35.

50. Alaska Club. *Album 1904* (Seattle: Covington-McDonald, 1904), 1.

51. "Alaska Given in Edition De Luxe," *Seattle Sunday Times,* March 24, 1907.

52. Terrence Cole, "Promoting the Pacific Rim: The Alaska-Yukon-Pacific Exposition of 1909," *Alaska History* 6, no. 1 (Spring 1991): 21.

53. Bagley, *History of Seattle*, 2:524.

54. Meany, "What It All Means."

55. Frykman, "The Alaska-Yukon-Pacific Exposition," 92.

56. Tom Griffin, "Centennial: How Fate, Visionaries and Some Shameless Boosters Transformed Logged-Over Land into the 'Most Beautiful' Campus in the Nation," *Columns Magazine,* University of Washington, http://www.washington.edu/alumni/columns/sept95/centennial.html

57. Norman Johnston, "The Olmsted Brothers and the Alaska-Yukon-Pacific Exposition: 'Eternal Loveliness,'" *Pacific Northwest Quarterly* 75, no. 2 (1984): 52.

58. Ibid., 57.

59. James M. Rupp, "1909 Seattle and the Alaska-Yukon-Pacific Exposition" (paper presented at the Monday Club, Seattle, June 1, 1998), 7.

60. Frank Merrick, "Ground Breaking Ceremonies of Alaska-Yukon-Pacific Exposition," *Alaska-Yukon Magazine* 3, no. 5 (July 1909): 420.

61. "A Memorable Enterprise: The AYPE and the City of Seattle," Seattle Municipal Archives, http://www.seattle.gov/CityArchives/Exhibits/AYPE/default.htm

62. This building is referred to as both the Manufacturers and the Manufactures Building in the A-Y-P literature.

63. Meany, "What It All Means."

64. Untitled description of eight buildings, A-Y-P Publicity File, University of Washington Libraries, Special Collections.

65. *Seattle Times,* February 3, 1909.

66. "Photographing Alaska for the Exposition," *Seattle Post-Intelligencer,* August 25, 1908, sec. 2; *Fairbanks Sunday Times,* September 14, 1908; "Prominent Men of Nome," *Alaska-Yukon Magazine* 7, no. 6 (1909): 521.

67. *Alaska-Yukon Magazine,* 1909, copy of page from Photographer's Reference File—Nowell, University of Washington Libraries, Special Collections.

68. Frank Merrick, "Exposition Publicity," *Alaska-Yukon Magazine* 5, no. 6 (September 1908): 451.

69. In the midst of Nowell's work, a family tragedy intervened in April 1909. He learned that his uncle George Nowell, who was in his seventies, had committed suicide by shooting himself while in a hotel room in Juneau.

70. Alaska-Yukon-Pacific Exposition, *Secretary's Report of the Alaska-Yukon-Pacific Exposition Held at Seattle June 1 to October 16, 1909* (Seattle: Gateway Printing Co., 1911), 16.

71. Don Duncan, *Meet Me at the Center: The Story of Seattle Center from the Beginnings to the 1962 Seattle's World Fair to the Twenty-first Century* (Seattle: Seattle Center Foundation, 1992), 14.

72. Robert W. Rydell, *All the World's a Fair: Visions of Empire at American International Expositions, 1876–1916* (Chicago: University of Chicago Press, 1984), 185.

73. Alaska-Yukon-Pacific Exposition, *Secretary's Report,* 23.

74. Alaska-Yukon-Pacific Exposition, *Official Daily Program,* June 27, 1909.

75. Cole, "Promoting the Pacific Rim," 28.

76. "Alaska-Yukon-Pacific Exposition, 1909—A Slide Show of Seattle's First World's Fair," HistoryLink, http://www.historylink.org/index.cfm?DisplayPage=output.cfm&file_id=7082

77. Alaska-Yukon-Pacific Exposition, *Official Daily Program,* July 30, 1909.

78. Ibid., 8.

79. Cole, "Promoting the Pacific Rim," 29.

80. Alaska-Yukon-Pacific Exposition, *Official Daily Program,* June 27, 1909. The Formosa Tea House exhibit was used to show how tea production had expanded since Japan seized Formosa in 1895; see Chinese in Northwest America Research Committee, "The Unexpected Fate of the Formosa Tea House," http://www.cinarc.org/AYPE.html#anchor_186

81. "Curtis to Exhibit New Volumes," *Seattle Daily Times,* May 9, 1909.

82. "Alaska-Yukon-Pacific Exposition, 1909—A Slide Show."

83. "The Alaska-Yukon-Pacific Exposition of 1909: Photographs by Frank H. Nowell," *Alaska Journal* 14, no. 3 (Summer 1984): 11.

84. Alaska-Yukon-Pacific Exposition, *The Exposition Beautiful,* 15.

85. Howard Droker, "On the Pay Streak at the Alaska-Yukon-Pacific Exposition," *Portage* 2, no. 3 (Summer 1981): 8.

86. The 1884 diorama of the Battle of Gettysburg still exists today. After years of neglect and damage, restoration work on it was finished in 2008. It is the largest single painting in the United States. See "A Renewed View of 'The Battle of Gettysburg,'" *Seattle Times,* October 12, 2008.

87. Julie K. Brown, *Contesting Images: Photography and the World's Columbian Exposition* (Tucson: University of Arizona Press, 1994), 105–6.

88. "Pay Streak Will Be Big Feature of Exposition," unidentified newspaper from A-Y-P Seattle Scrapbook 6, University of Washington Libraries, Special Collections.

89. On harrassment of the Chinese, see Shelley S. Lee, "The Contradictions of Cosmopolitanism: Consuming the Orient at the Alaska-Yukon-Pacific Exposition and the International Potlatch Festival, 1909–1934," *Western Historical*

Quarterly 38, no. 3 (Autumn 2007): 7–10. On the Chinese Village, see Chinese in Northwest America Research Committee, "The Chinese Village Makes a Profit," http://www.cinarc.org /AYPE

90. "The Pay Streak," *Alaska-Yukon-Pacific Weekly News,* 1909.

91. Rupp, "1909 Seattle and the A-Y-P," 19.

92. Duncan, *Meet Me at the Center,* 16.

93. Lee, *Contradictions of Cosmopolitanism,* 9–10.

94. Chuiemei Ho and Bennet Bronson, "The Dragon at the A-Y-P," paper presented at the Pacific Northwest Historian's Guild meeting, Seattle, March 7, 2009; Chinese in Northwest America Research Committee, "The AYPE's Former President Remembers Asian VIPs," http: //www.cinarc.org/AYPE

In *All the World's a Fair,* Robert Rydell argues that American world's fairs served to legitimize imperialism and racism through exhibits of minorities. However, Rydell neglects to present imperialism in a world-wide context. For example, the Japanese used world's fairs to exhibit and legitimize lands recently seized from China. Rydell also presents a one-dimensional view of minorities participating only as helpless victims of exploitation. In fact, the participation of minorities at American fairs is far more complex, and other researchers have examined their participation in a different light. For example, the Chinese in Northwest America Research Committee discusses issues of Asian participation in world's fairs as "Windows for Developing a New Chinese-American Consciousness."

95. Alan J. Stein, "Smith Day Is Celebrated at the A-Y-P on September 2, 1909" History-Link, http://www.historylink.org/index .cfm?DisplayPage=output.cfm&file_id=8198

96. Janet A. Northam and Jack W. Berryman, "Sport and Urban Boosterism in the Pacific Northwest: Seattle's Alaska-Yukon-Pacific Exposition, 1909, *Journal of the West* 17, no. 3 (1978): 55.

97. Ibid., 56–57.

98. "Exposition Flag Flying on Mt. Rainier," *Seattle Daily Times,* August 2, 1909.

99. "Doesn't Believe They Made Ascent," ibid., August 8, 1909.

100. Rupp, "1909 Seattle and the A-Y-P," 14.

101. Terrence Cole, "Ocean to Ocean by Model T Ford and the Transcontinental Auto Contest," *Journal of Sport History* 18, no. 2 (Summer 1991): 229.

102. Ford Motor Company, *Story of the Race* (1959?), reprint of *The Story of the Race: How the Ford Car Won the Transcontinental Contest for the Guggenheim Trophy Told by One of the Crew on Ford Car No. 1* (1909?), 13.

103. Cole, "Ocean to Ocean," 236.

104. Northam and Berryman, "Sport and Urban Boosterism," 58.

105. "Arctic Brethren to Lay First Cabin Log," *Seattle Times,* November 1, 1908; "Judge Turns Over Home of Arctic Brotherhood," ibid., June 1, 1909.

106. Robert Monroe, "Up in the Air: On Balloons and Photography in Washington in 1909," *Northwest Photography,* June 1982, 4.

107. "English Papers Ask Pictures of Fair," *Seattle Daily Times,* May 11, 1909, p. 8.

108. Alaska-Yukon-Pacific Exposition, *Secretary's Report,* 16, 18.

109. Mick Gidley, *Edward Curtis and the North American Indian Incorporated* (New York: Cambridge University Press, 1998), 61.

110. R.T. Jones to Robert Monroe, October 12, 1965, Photographer's Reference File—R.T. Jones, University of Washington Libraries, Special Collections.

111. Ibid.

112. Nowell also issued photographs of Alaska made from negatives collected from other photographers. He did not number them as part of the X-number system.

113. "Cameras to Enter Gates Free" (1908?), unidentified newspaper from A-Y-P Seattle Scrapbook 3.

114. Postcard from Ruth to Mrs. Lena B. Williston, July 23, 1909, in A-Y-P Postcard Collection, University of Washington Libraries, Special Collections.

115. "Free Admittance Will Be Granted Cameras," *Seattle Daily Times,* October 28, 1908.

116. "Post Card Company Has Grievance," ibid., December 11, 1908.

117. "Post Card Contest to Advertise Fair," ibid., May 16, 1909.

118. Rupp, "1909 Seattle and the A-Y-P," 22.

119. *Seattle Star,* August 27, 1909.

120. Questions of which buildings were intended to be permanent, and when and why it was decided to keep additional buildings as part of the campus, are complex and occasionally confusing, with sources ranging from contemporary newspaper articles to information buried in reports of the university regents. Jeffrey Ochsner of the university's Department of Architecture and Paula Becker of HistoryLink provided helpful background and clarification. See also Kathryn Rogers Merlino, "Classicizing the Wilderness: The Forestry Building at the A-Y-P," paper presented at the meeting of the Pacific Northwest Historians Guild, Seattle, March 6–7, 2009. A useful online history of university buildings can be found at http://www.washington.edu/admin/pb/home/ pdf/UW-Buildings-History.pdf

121. "A Memorable Enterprise: The AYPE and the City of Seattle."

122. Rupp, "1909 Seattle and the A-Y-P," 23.

123. During this time Nowell's studio in Nome was managed by W. H. Moldt; Nowell is listed in the directory as the photographer and Moldt as the manager. See *Polk's Alaska-Yukon Gazetteer and Business Directory* (Seattle, 1911–1912), 389.

124. It is possible that the Nowell & Rognon photographs were done by Rognon.

125. "Nowell Family Helped to Make History in Klondike Vastness," *Seattle Daily Times,* July 16, 1922.

126. Ralph Andrews, *Photographers of the Frontier West: Their Lives and Works, 1875 to 1915* (Seattle: Superior, [1965]), 40.

127. Author's interview with Robert Curry, Summer 2007.

128. Andrews, *Photographers of the Frontier West,* 40.

129. Alan J. Stein, "Century 21: The 1962 Seattle World's Fair Part 1," HistoryLink http://www .historylink.org/index.cfm?DisplayPage=output .cfm&file_id=2290

130. W.H. Raymond, "Uncle Sam's Next Big Show," *Sunset Magazine,* May 1909, 449.

ALASKA PHOTOGRAPHS

· BY FRANK H. NOWELL ·

· **PLATE I** ·
Mining operation at Buster Creek, Nome,
Alaska, October 10, 1906.

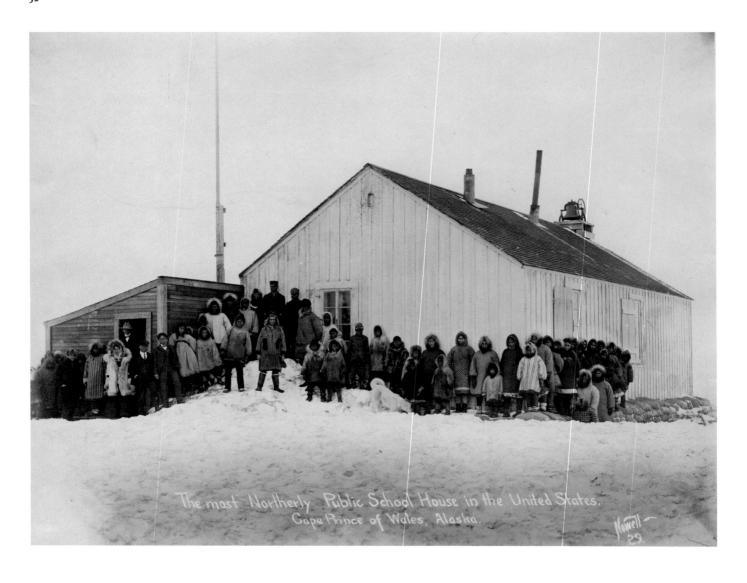

The most Northerly Public School House in the United States.
Cape Prince of Wales, Alaska.

Nowell
29

· PLATE 2 ·

"The Most Northerly Public School House in
the United States": O. J. Rognon and Suzanne R.
Bernardi's school and pupils at Cape Prince
of Wales, Alaska, ca. 1902.

PHOTO BY FRANK H. NOWELL. UNIVERSITY OF WASHINGTON
LIBRARIES, SPECIAL COLLECTIONS, NA2156.

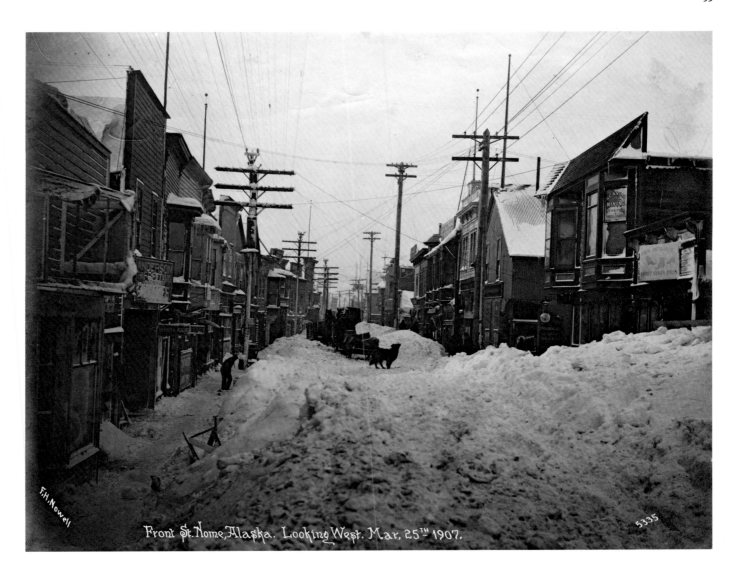

· PLATE 3 ·

Front Street, Nome, Alaska, March 25, 1907.

PHOTO BY FRANK H. NOWELL. UNIVERSITY OF WASHINGTON
LIBRARIES, SPECIAL COLLECTIONS, NOWELL 5335.

Miocene Ditch Co. hydraulicking on Schow Mine, Glacier Creek, July 14ᵀᴴ 1906.

· PLATE 4 ·
Hydraulic mining at Glacier Creek,
near Nome, July 14, 1906.

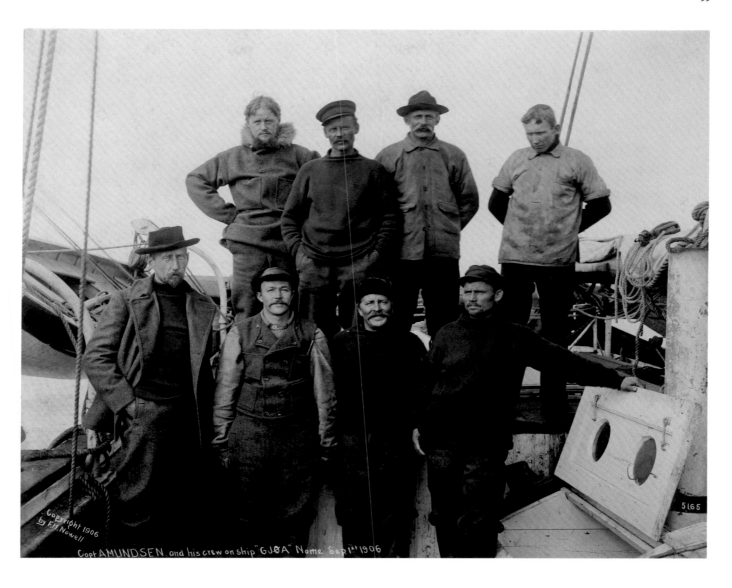

Copyright 1906
by F.H. Nowell

Capt. AMUNDSEN. and his crew on ship "GJØA" Nome Sep. 1st 1906

5165

· PLATE 5 ·
Captain Roald Amundsen and his crew
on board the *Gjøa*, Nome, September 1, 1906.
PHOTO BY FRANK H. NOWELL. UNIVERSITY OF WASHINGTON
LIBRARIES, SPECIAL COLLECTIONS, NOWELL 5165.

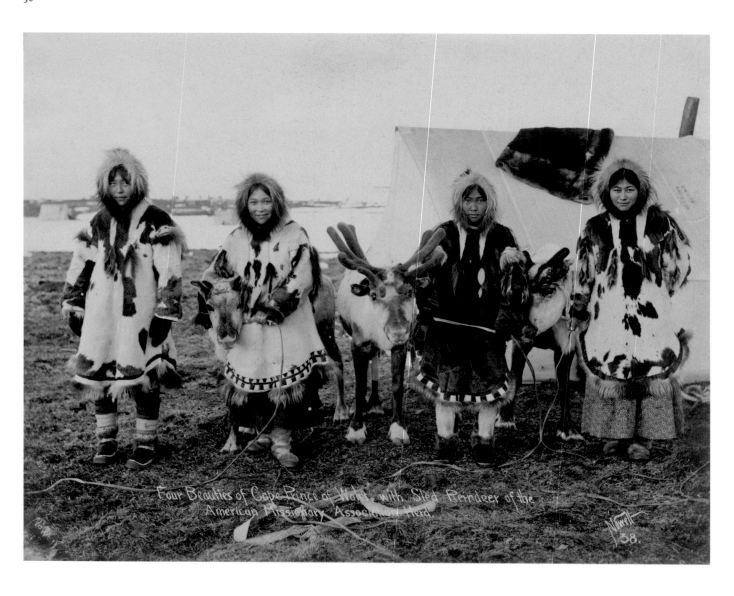

Four Beauties of Cape Prince of Wales with Sled Reindeer of the
American Missionary Association Herd.

· **PLATE 6** ·
Eskimo women with reindeer,
Cape Prince of Wales, Alaska, ca. 1902.
PHOTO BY FRANK H. NOWELL. UNIVERSITY OF WASHINGTON
LIBRARIES, SPECIAL COLLECTIONS, NA2158.

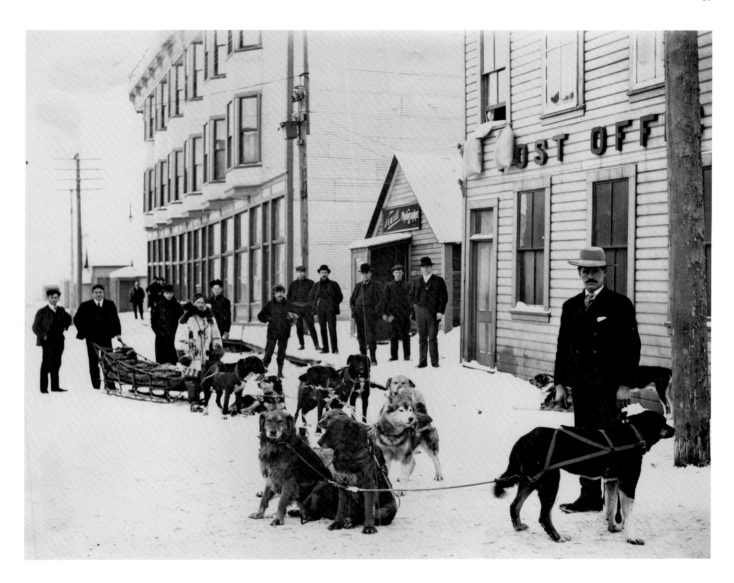

· **PLATE 7** ·
Mail carrier M. L. V. Smith with his dogsled
team bringing mail from Unalakleet to the
Nome Post Office, December 16, 1905. Frank
Nowell's studio can be seen between the
Golden Gate Hotel and the Post Office.
PHOTO BY FRANK NOWELL. UNIVERSITY OF WASHINGTON
LIBRARIES, SPECIAL COLLECTIONS, NOWELL 4758.

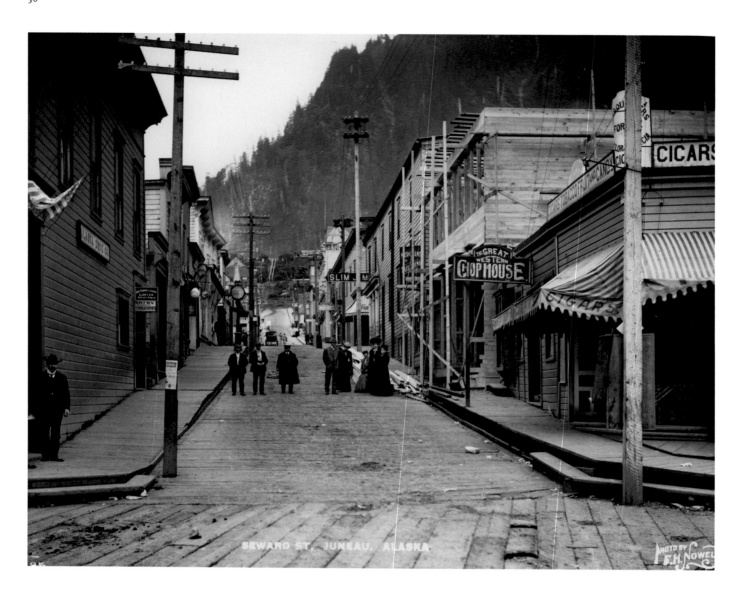

· PLATE 8 ·
Seward Street, Juneau, Alaska.
PHOTO BY FRANK H. NOWELL. UNIVERSITY OF WASHINGTON
LIBRARIES, SPECIAL COLLECTIONS, NOW070.

· **PLATE 9** ·
From A-Y-P photographic tour: Bessie Road
House, Third Beach Line, near Nome,
September 29, 1908.

A-Y-P PHOTOGRAPHS

· BY FRANK H. NOWELL ·

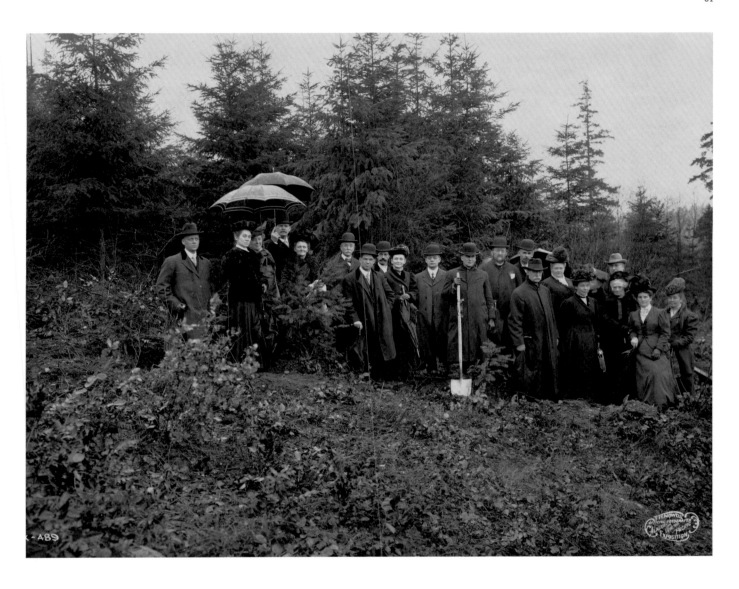

· **PLATE 10** ·
Ground-breaking for the Baptist Headquarters
Building, February 22, 1908.

PHOTO BY FRANK H. NOWELL. UNIVERSITY OF WASHINGTON
LIBRARIES, SPECIAL COLLECTIONS, NOWELL X489.

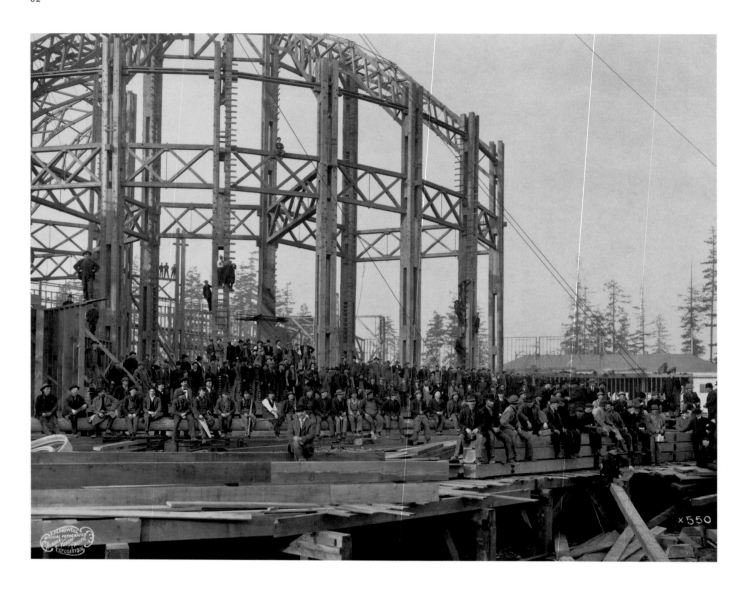

· **PLATE II** ·
Construction of the U.S. Government Building,
March 12, 1909.

PHOTO BY FRANK H. NOWELL. UNIVERSITY OF WASHINGTON
LIBRARIES, SPECIAL COLLECTIONS, NOWELL X550.

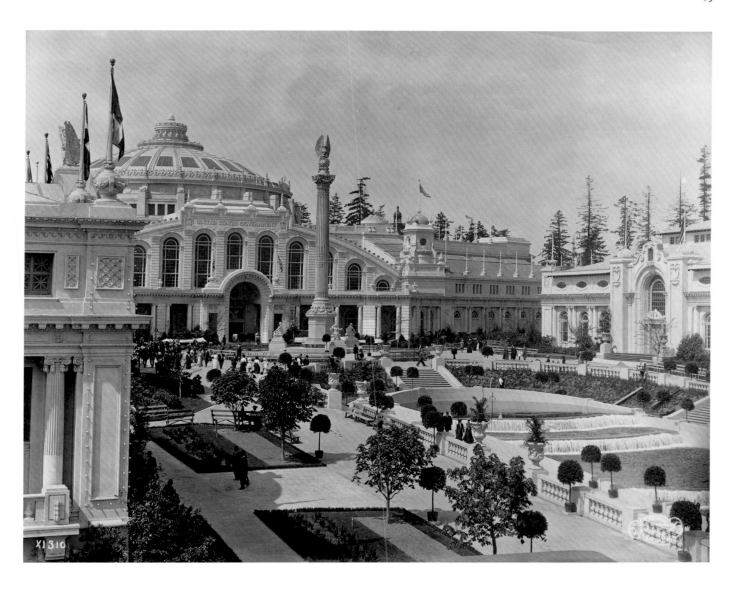

· **PLATE 12** ·
Court of Honor, with the Alaska Monument
in front of the U.S. Government Building, 1909.
PHOTO BY FRANK H. NOWELL. UNIVERSITY OF WASHINGTON
LIBRARIES, SPECIAL COLLECTIONS, NOWELL X1310.

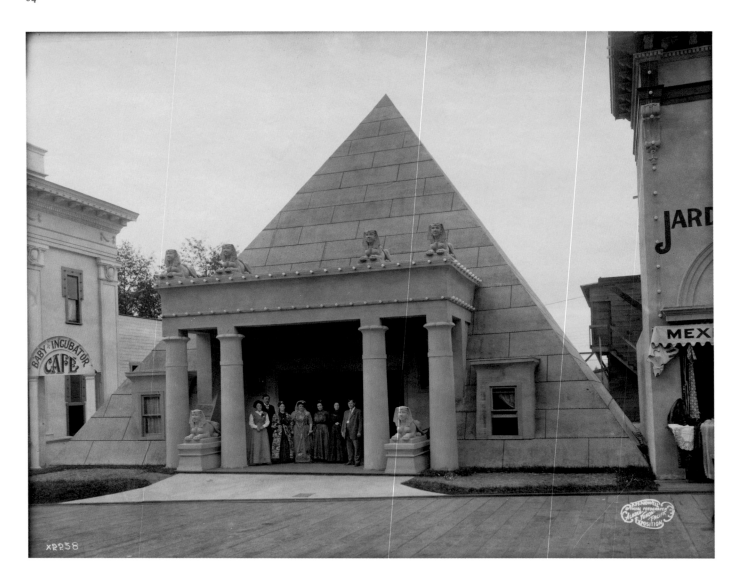

· **PLATE 13** ·
Temple of Palmistry on the Pay Streak, 1909.
PHOTO BY FRANK H. NOWELL. UNIVERSITY OF WASHINGTON
LIBRARIES, SPECIAL COLLECTIONS, NOWELL X2258.

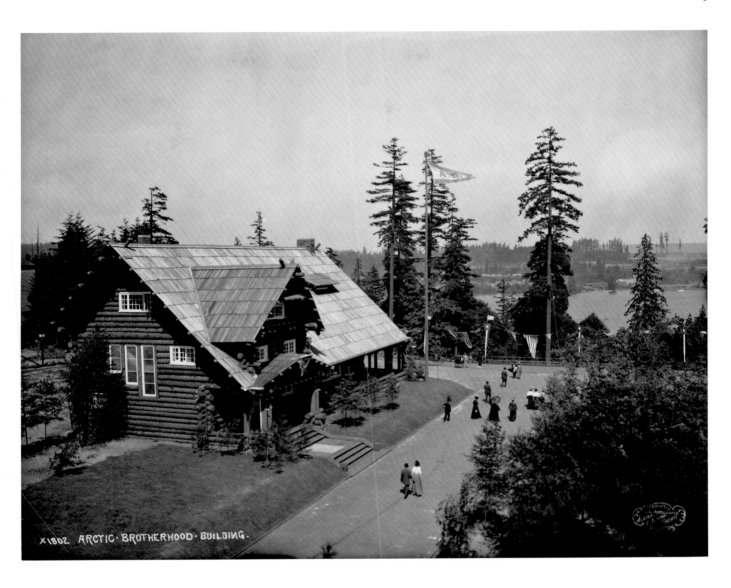

X1802 ARCTIC · BROTHERHOOD · BUILDING ·

· PLATE 14 ·
Arctic Brotherhood Building, July 1909.
PHOTO BY FRANK H. NOWELL. UNIVERSITY OF WASHINGTON
LIBRARIES, SPECIAL COLLECTIONS, NOWELL X1802.

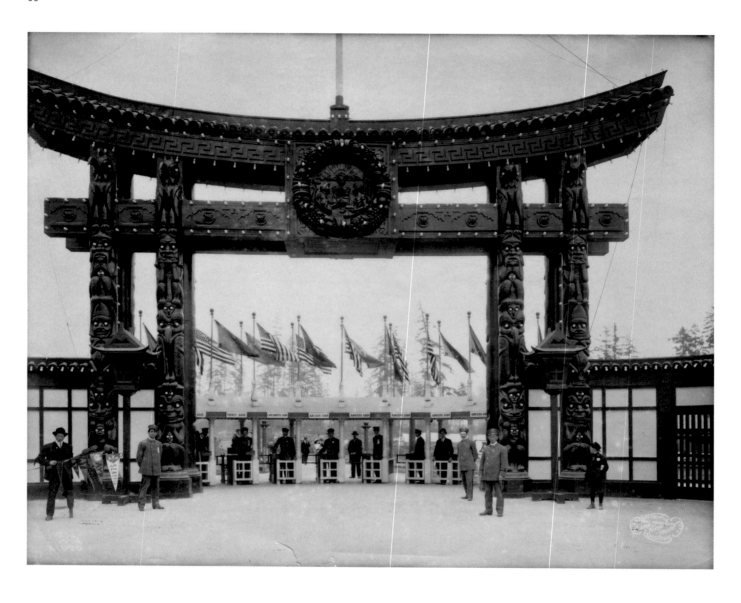

· **PLATE 15** ·
Torii gate at south entrance, 1909.

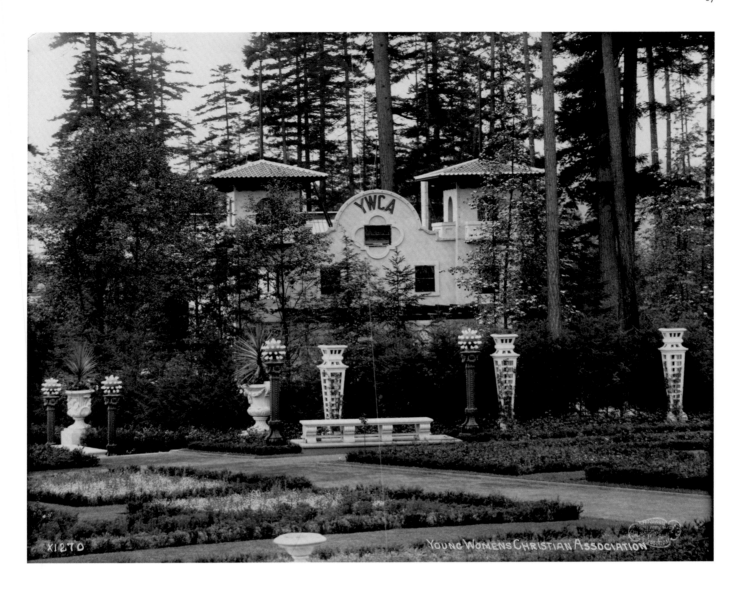

· **PLATE 16** ·
Young Women's Christian Association (YWCA)
Building, 1909.

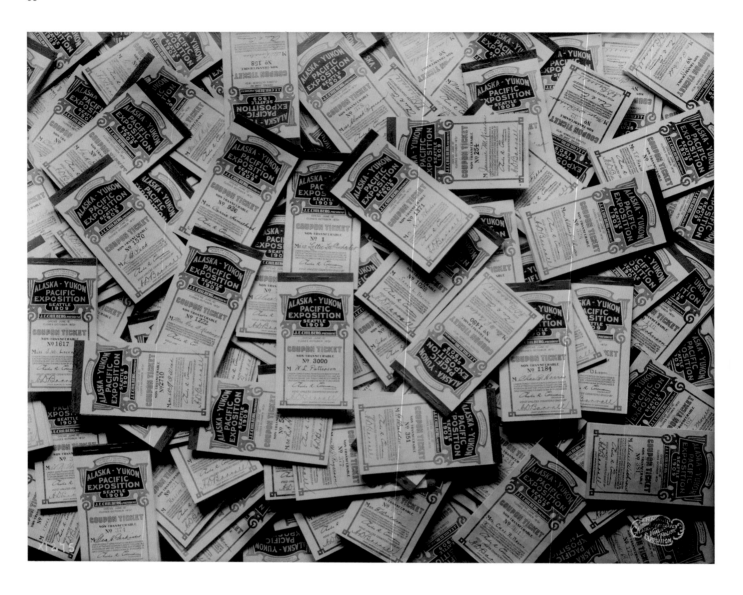

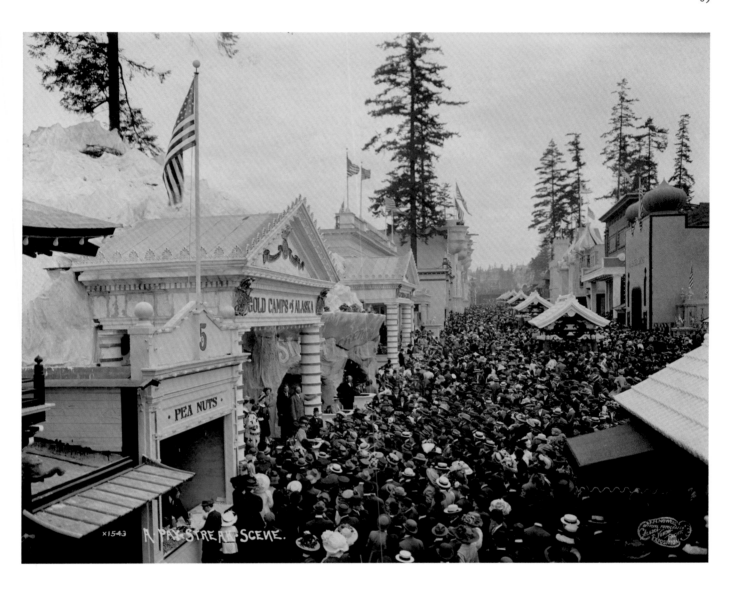

· PLATE 18 ·
Looking north on the Pay Streak, 1909.
PHOTO BY FRANK H. NOWELL. UNIVERSITY OF WASHINGTON
LIBRARIES, SPECIAL COLLECTIONS, NOWELL X1543.

70

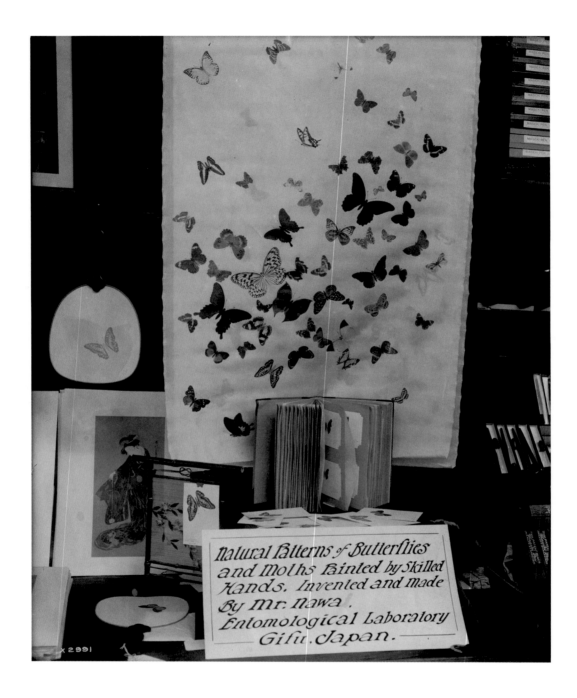

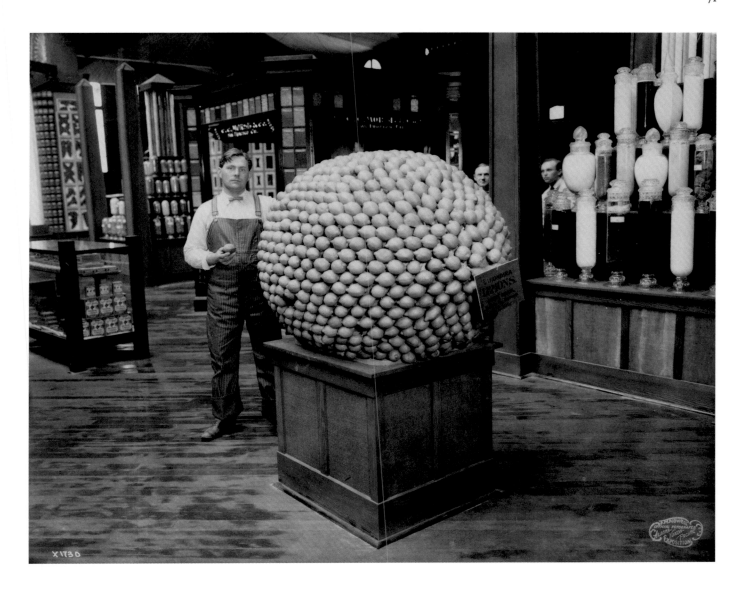

· **PLATE 20** ·
Giant lemon made with lemons
in the California Building, 1909.
PHOTO BY FRANK H. NOWELL. UNIVERSITY OF WASHINGTON
LIBRARIES, SPECIAL COLLECTIONS, NOWELL X1730.

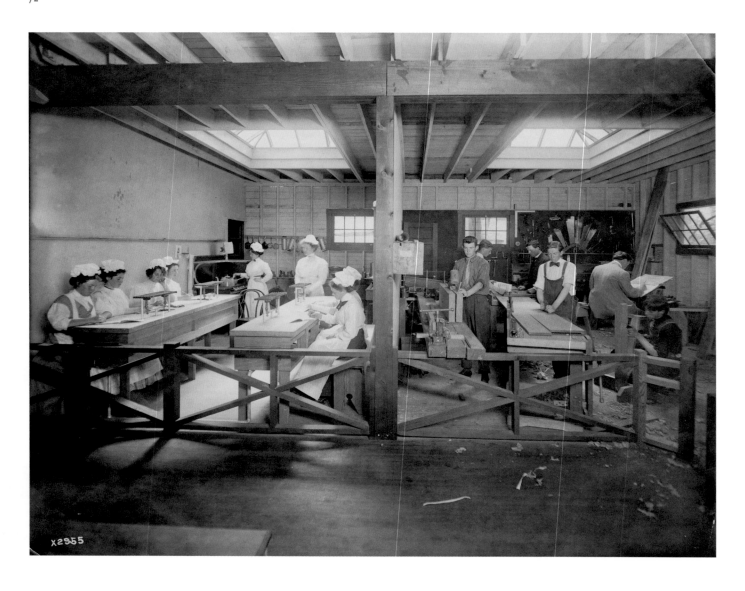

X2955

· **PLATE 21** ·
Olympia High School students working
in model kitchen and manual training
workshop in the Washington State
Education Building exhibit, 1909.
Photo by Frank H. Nowell. University of Washington
Libraries, Special Collections, UW27533.

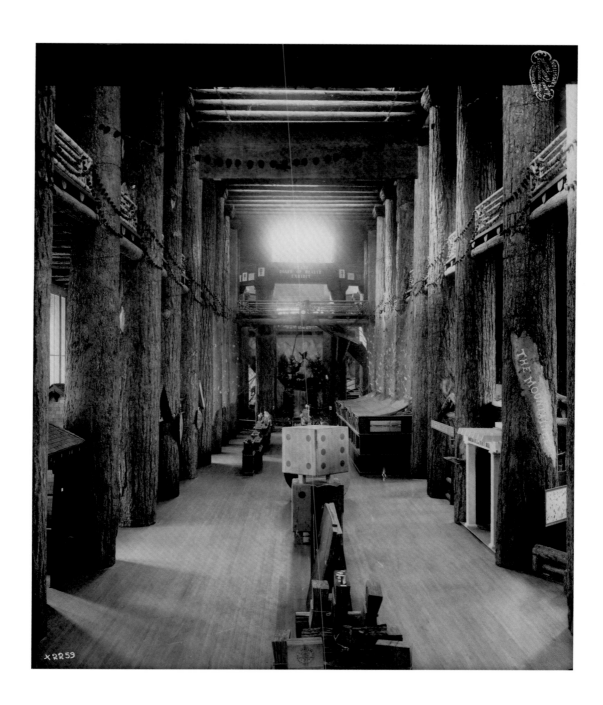

· **PLATE 22** ·
View of the Forestry Building interior
including large wooden dice, 1909.

74

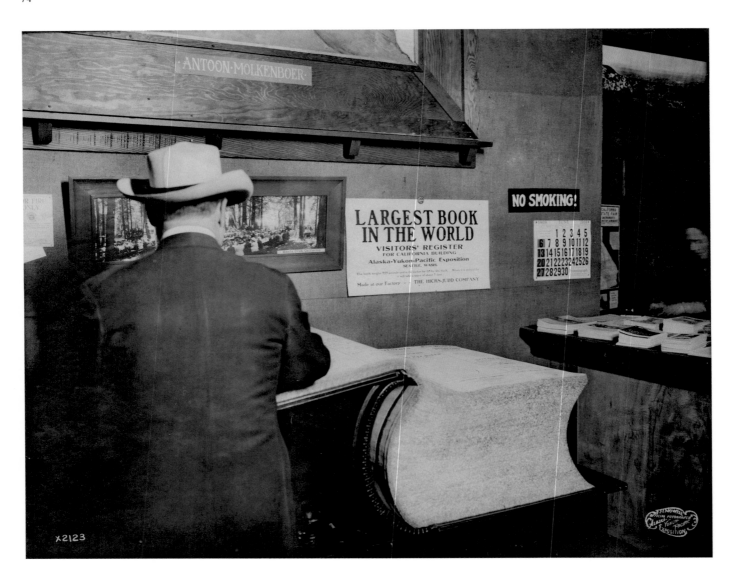

· **PLATE 23** ·
"Largest Book in the World" exhibit
in the California Building, 1909.

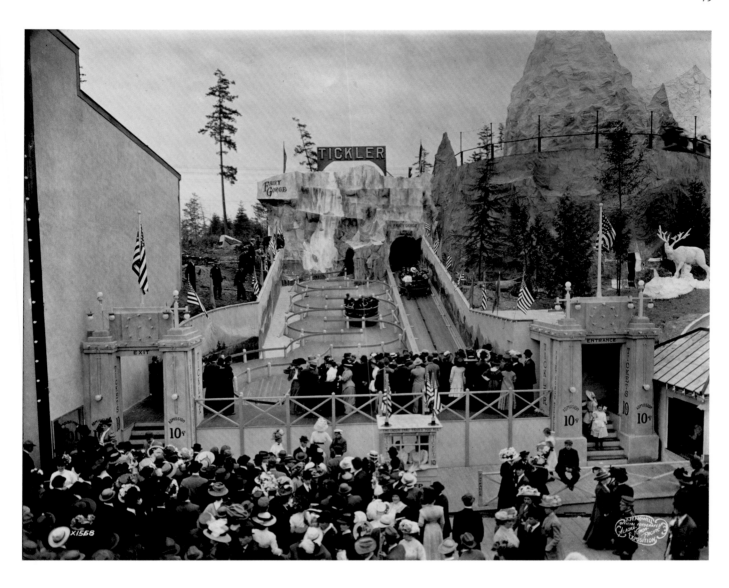

Fairy Gorge Tickler amusement ride
on the Pay Streak, 1909.

PHOTO BY FRANK H. NOWELL. UNIVERSITY OF WASHINGTON
LIBRARIES, SPECIAL COLLECTIONS, NOWELL X1568.

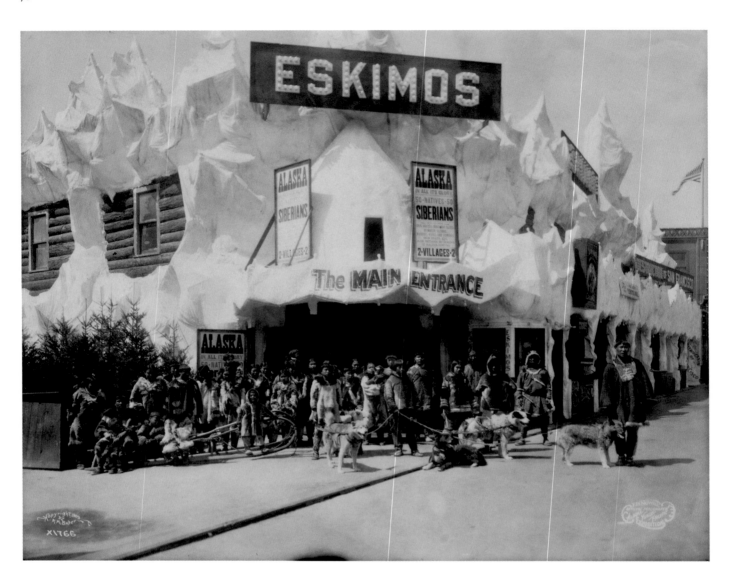

· **PLATE 25** ·
Eskimo Village on the Pay Streak, 1909.
Photo by Frank H. Nowell. University of Washington
Libraries, Special Collections, Nowell x1766.

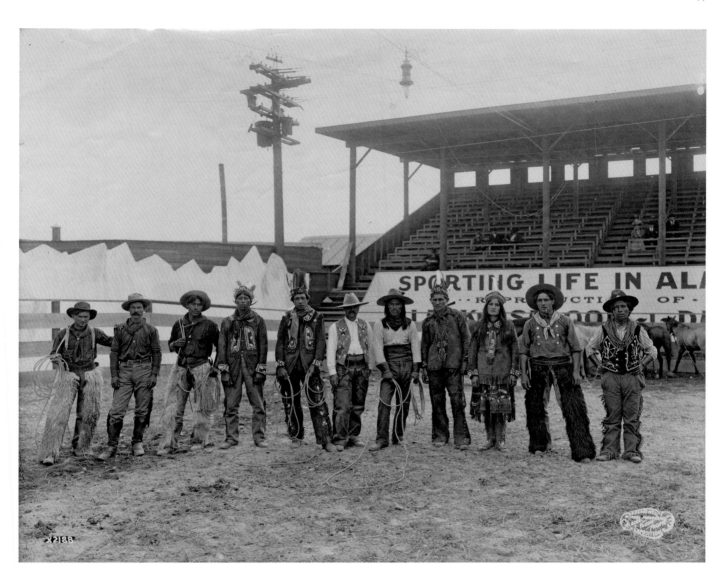

· **PLATE 26** ·
Wild West Show members, 1909.
PHOTO BY FRANK H. NOWELL. UNIVERSITY OF WASHINGTON
LIBRARIES, SPECIAL COLLECTIONS, NOWELL X2188.

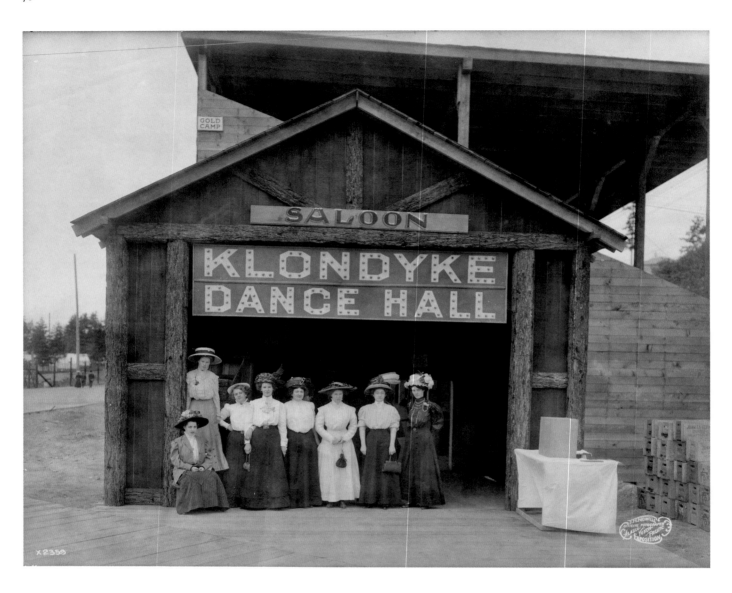

· **PLATE 27** ·
Klondyke Dance Hall on the Pay Streak, 1909.
PHOTO BY FRANK H. NOWELL. UNIVERSITY OF WASHINGTON
LIBRARIES, SPECIAL COLLECTIONS, NOWELL X2359.

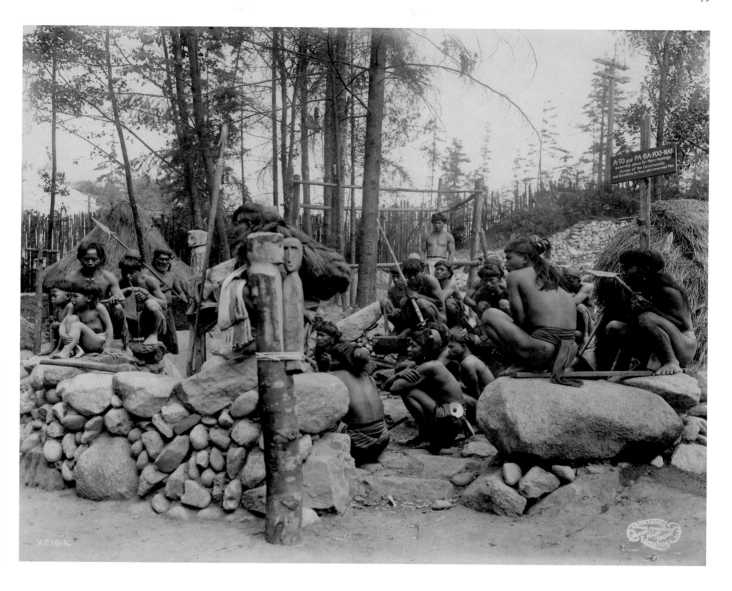

· **PLATE 28** ·

Men in Igorrote Village on the Pay Streak, 1909.

PHOTO BY FRANK H. NOWELL. UNIVERSITY OF WASHINGTON
LIBRARIES, SPECIAL COLLECTIONS, NOWELL X2164.

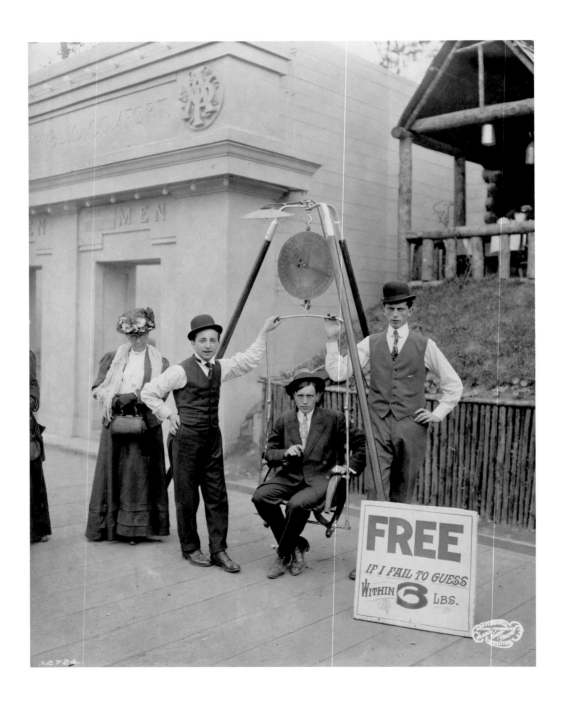

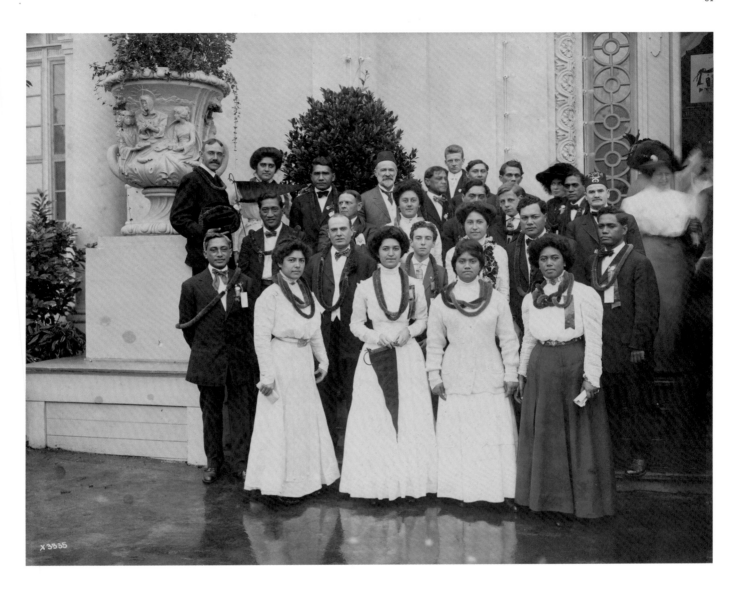

· **PLATE 30** ·
Hawaiian officials, hostesses, and musicians
in front of the Hawaii Building, 1909.
PHOTO BY FRANK H. NOWELL. UNIVERSITY OF WASHINGTON
LIBRARIES, SPECIAL COLLECTIONS, NOWELL X3535.

· PLATE 31 ·

Elks Club members in front of the Official
Photographer Building on the Pay Streak,
July 1909. Nowell's photographs can be
seen printed on large glass panels.

PHOTO BY FRANK H. NOWELL. UNIVERSITY OF WASHINGTON
LIBRARIES, SPECIAL COLLECTIONS, NOWELL X3064.

The Prize Winners, Smith Family Day, A.Y.P. Exposition, Sept. 2, 1909.

· **PLATE 32** ·

Smith Day prize-winners on the Auditorium
steps, September 2, 1909.

· **PLATE 33** ·
Arrival of the Ford Model T car no. 2,
winner of the transcontinental race
from New York to Seattle, June 1909.
Henry Ford and Robert Guggenheim are
in the crowd standing near the automobile.

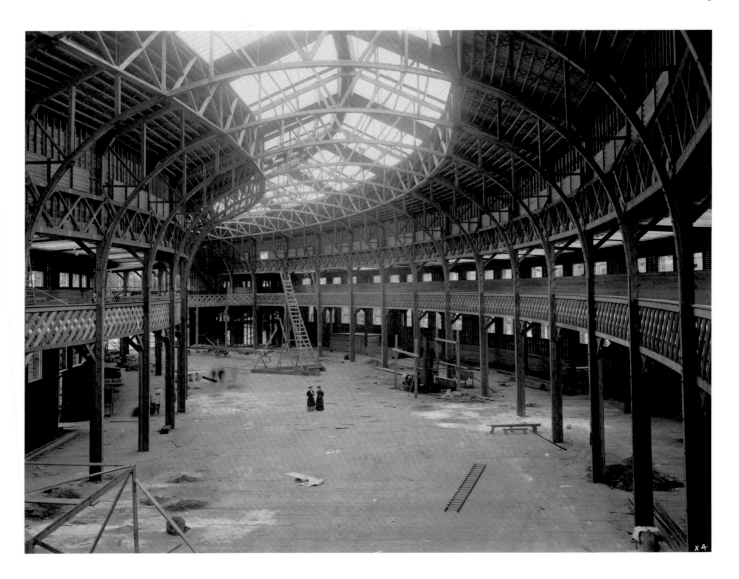

· **PLATE 34** ·
Interior of the Manufactures Building
under construction, March 8, 1908.
PHOTO BY FRANK H. NOWELL. UNIVERSITY OF WASHINGTON
LIBRARIES, SPECIAL COLLECTIONS, NOWELL X4.

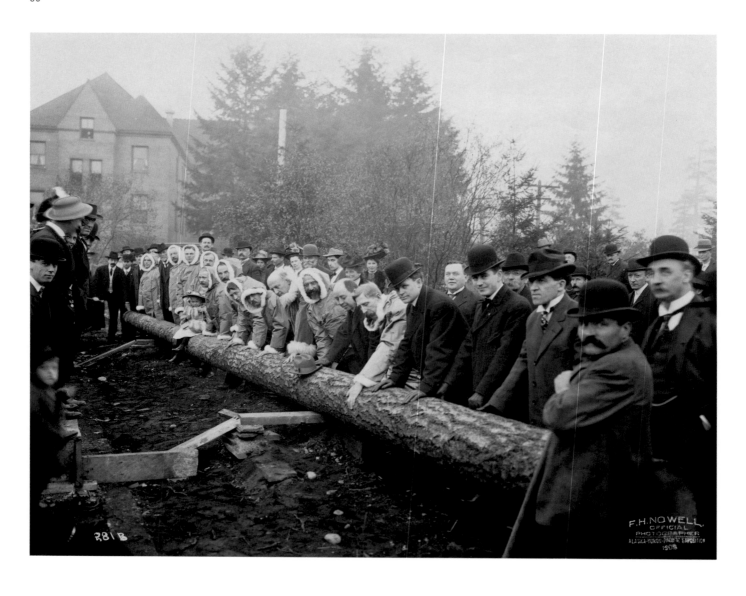

· **PLATE 35** ·
Ceremony to lay the first log for the Arctic
Brotherhood Building, November 1908.
PHOTO BY FRANK H. NOWELL. UNIVERSITY OF WASHINGTON
LIBRARIES, SPECIAL COLLECTIONS, NOWELL X281B.

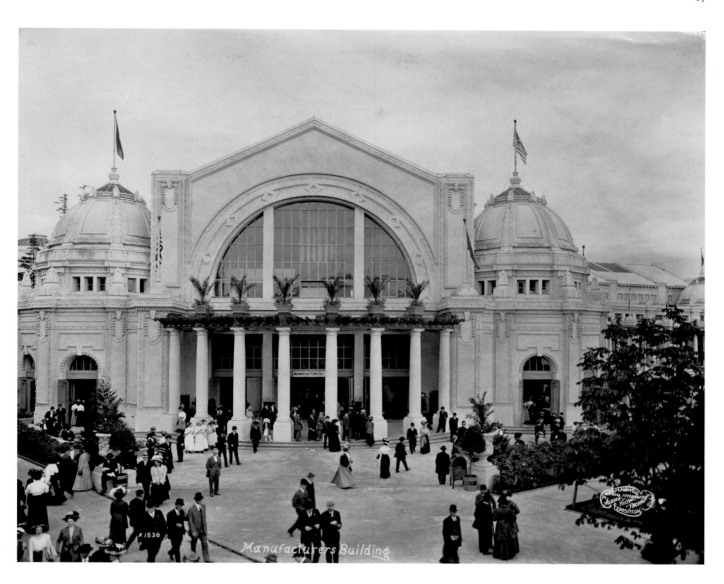

· **PLATE 36** ·

Front of the Manufactures Building, 1909.

PHOTO BY FRANK H. NOWELL. UNIVERSITY OF WASHINGTON
LIBRARIES, SPECIAL COLLECTIONS, NOWELL X1538.

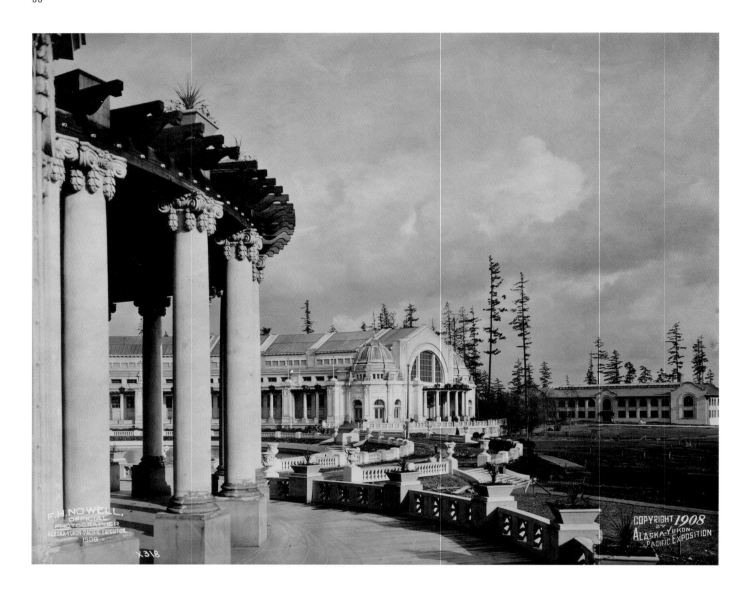

· **PLATE 37** ·
Looking toward the Manufactures Building
from the Agriculture Building, November 1908.
This photo is an example of the early use of
the caption "Copyright 1908 by Alaska-Yukon-
Pacific Exposition." Some early Nowell
photographs were issued using this credit
without also using his name.
PHOTO BY FRANK H. NOWELL. UNIVERSITY OF WASHINGTON
LIBRARIES, SPECIAL COLLECTIONS, NOWELL X318.

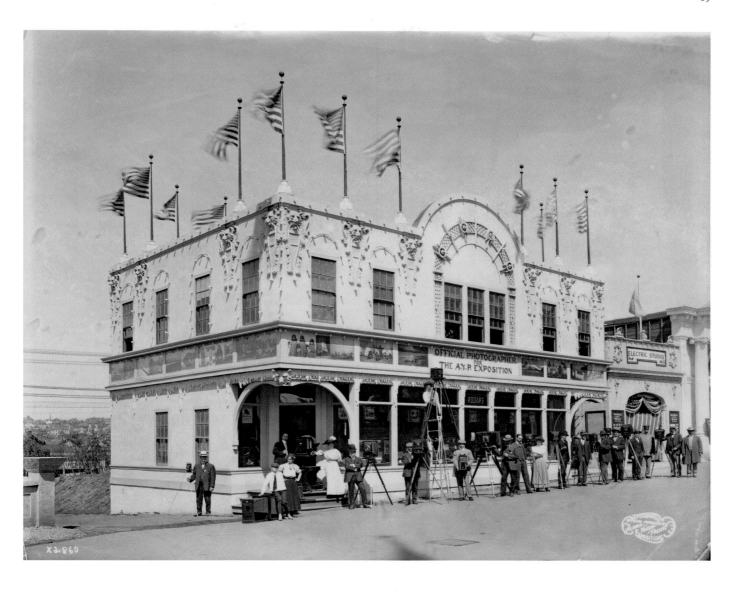

· **PLATE 38** ·
Official Photographer Building, 1909.

PHOTO BY FRANK H. NOWELL. UNIVERSITY OF WASHINGTON
LIBRARIES, SPECIAL COLLECTIONS, NOWELL X2860.

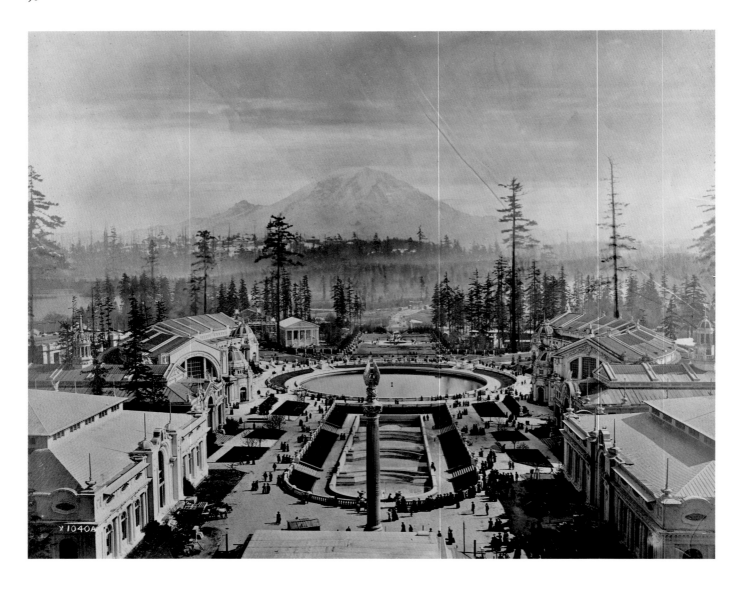

· **PLATE 39** ·
View of the exposition from the top of
the U.S. Government Building looking toward
Mount Rainier, 1909. This photograph has
been printed from two negatives; one
photograph was of the fair grounds and
the other was of Mount Rainier.
PHOTO BY FRANK H. NOWELL. UNIVERSITY OF WASHINGTON
LIBRARIES, SPECIAL COLLECTIONS, NOWELL XI040A.

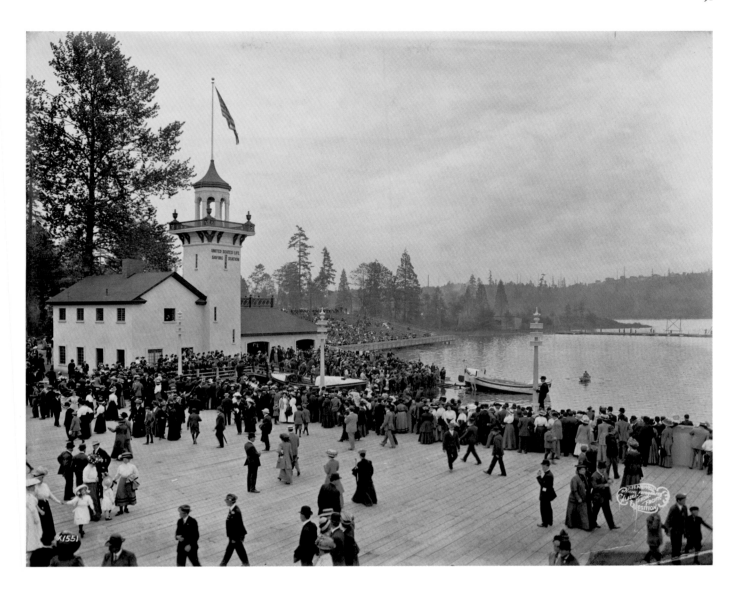

· **PLATE 40** ·
U.S. Life Saving Station at the end
of the Pay Streak, 1909.

Photo by Frank H. Nowell. University of Washington
Libraries, Special Collections, Nowell X1551.

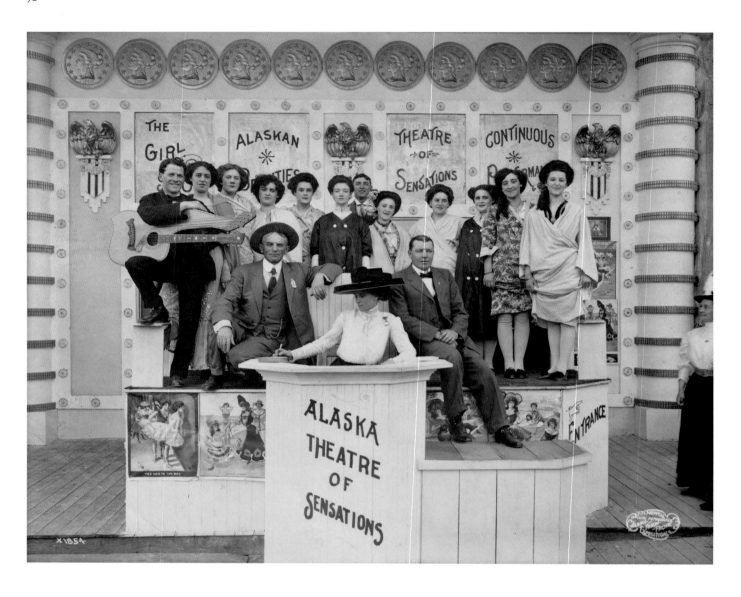

· **PLATE 41** ·
Alaska Theatre of Sensations
on the Pay Streak, 1909.
Photo by Frank H. Nowell. University of Washington
Libraries, Special Collections, Nowell X1854.

· **PLATE 42** ·
Small urn and trees behind the
Agriculture Building, 1909.

PHOTO BY FRANK H. NOWELL. UNIVERSITY OF WASHINGTON
LIBRARIES, SPECIAL COLLECTIONS, NOWELL X1087.

THE A·Y·P REPHOTOGRAPHIC PROJECT

· BY JOHN STAMETS ·

Rephotographing the A-Y-P was fascinating, boring, and challenging all at once: Fascinating because we were always imagining a fabulously spectacular ghost campus that existed here at the University of Washington only a hundred years ago. Boring because many of the same views taken today from the same perspectives can be downright dull. And challenging because we tried to respect the historic views while at the same time conveying a meaningful sense of the campus landscape as it exists today.

This rephotographic project started as an effort to introduce large-format film photography into the curriculum at the University of Washington Department of Architecture. Historically this has been the format for professional architectural photography, and it still has validity today despite the overall dominance of digital photography.

For this ongoing class project, the A-Y-P made a very suitable subject, because all the shooting would occur very close to our home base in Gould Hall. Also, the historic photographs were made on large-format cameras, very similar to the ones we use today, so there was a spiritual connection to the past as well. The major photographic difference is that in 1909 the photographers were shooting on 8" × 10" glass plates, whereas today we are shooting on 4" × 5" film.

The major impact of the A-Y-P at the university was the creation, in one quick swoop, of an entire south campus out of second-growth forest. Since most of the buildings were constructed cheaply and then demolished soon after the fair

ended, the lasting legacy of the A-Y-P one hundred years later is the *landscape* of the south campus, not its buildings. Rainier Vista and Drumheller Fountain today (plate 55B) are virtually the same as they were in 1909 except that the original Geyser Basin was wider in diameter. Thus the easiest places to rephotograph the A-Y-P today are along Rainier Vista, south from Red Square to Montlake Boulevard.

Only two A-Y-P buildings survive on campus in recognizable form, and both are represented here. The more intact of these is today's Architecture Hall (plate 62B), seemingly unchanged in exterior appearance. It was built as one of several permanent buildings that the exposition promised to the university. Designed as a state-of-the-art college chemistry building, it opened for classes in spring 1910. During the previous summer at the A-Y-P, it was the fair's art museum, called the Palace of Fine Arts or the Fine Arts Building. Today's Cunningham Hall (plate 64B) opened at the A-Y-P as the Washington State Women's Building. It was not intended to be a permanent building, but it was sturdy, especially after a renovation in the 1970s, and it has remained in continuous use. Another surviving A-Y-P building on campus has been altered significantly with additions. Originally known as the Foundry, it is now part of the Engineering Annex (plate 71B).

Except for those three survivors we can only imagine where and how the rest of the A-Y-P buildings once stood on today's campus. This is where the rephotography gets challenging.

Oddly, the locations of some of the major A-Y-P buildings are open spaces today, while many open spaces in 1909 are now occupied by newer buildings. For instance, the footprint of the Government Building, the largest building at the fair, is almost exactly the same as today's sprawling open Red Square. And on the southwest side of Red Square, the new Meany Hall occupies the large open landscape that in 1909 was just inside the fair's entrance at NE 40th Street. As a photographer trying to rephotograph the A-Y-P, I find the new Meany Hall my least favorite campus building because it blocks so many potential views.

Thus it is usually impossible to stand today exactly where the historic photographer stood in 1909. Or if it is possible, the exact same view today might be just a blank brick wall or a thicket of trees—not very useful for envisioning the overlap of past and present. Therefore, most of the modern images on these pages are *approximate* rephotographs, but they all endeavor to show the same general area where the historic subject once stood.

When it was impossible to stand at the same location as the historic photographer, we would try to stand as close as possible while balancing various factors, such as lighting conditions, lines of sight, angles of view (lens focal length), and/or the presence of pedestrians.

To approximate the lighting conditions at the A-Y-P, the obvious choice would be to shoot only in the summer months. But in summer the trees are filled with leaves, which can significantly obscure the buildings behind them. Today there are a lot more trees on the campus than there were in 1909. Therefore many of our best rephotographs were taken in the winter months. Although the angle of the light was usually wrong, at least we could see today's built environment through the leafless branches.

The A-Y-P photographer Frank Nowell had one tool that we did not have: an extremely tall tripod, approximately seventeen feet high, and the courage to use it. This allowed high perspectives that showed the ground plane and pathways in much better perspective than would be possible if the camera were at ground level. Some of the best views of the fair were taken from this high tripod. For a few rephotographs we used a twelve-foot tripod and a stepladder. That was scary enough for me, but convinced me of the validity of the technique for photographing designed landscapes.

Given all the constraints it was not always easy to come up with good photographs, but here is what we have as this book goes into production. With each class of students, the results are getting better, and the project will continue through the summer of 2009, the hundredth anniversary of the A-Y-P.

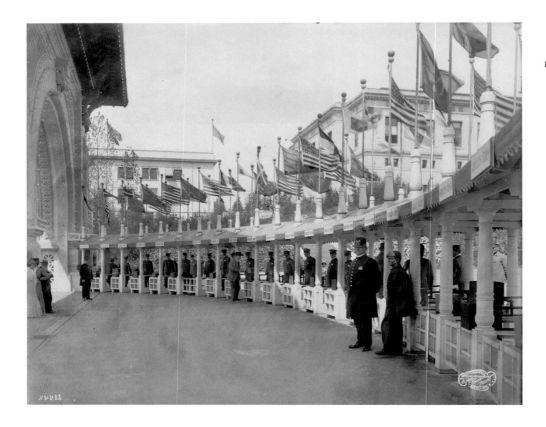

· **PLATE 43A** ·
Main entrance gate, 1909.

· **PLATE 43B** ·
Looking north from the
NE 40th Street entrance, 2007.

George Washington statue
unveiling, June 14, 1909.
PHOTO BY FRANK H. NOWELL. UNIVERSITY
OF WASHINGTON LIBRARIES, SPECIAL
COLLECTIONS, NOWELL X1971.

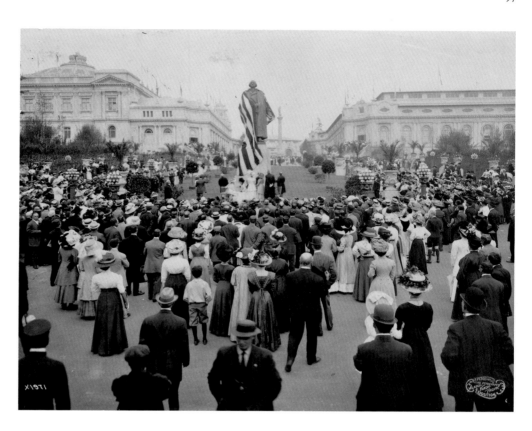

George Washington statue, 2007.
The statue today is located
several hundred feet north of
its original location at the A-Y-P,
but it still faces west.
PHOTO BY JAY FLAMING.

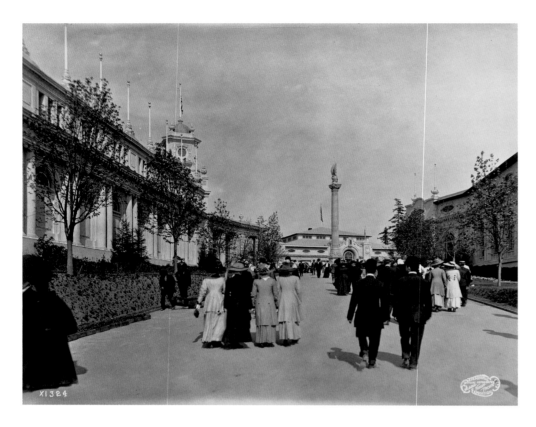

· PLATE 45A ·
Exposition visitors walking
along Olympic Place toward
the Court of Honor and the
Alaska Monument, 1909.
PHOTO BY FRANK H. NOWELL. UNIVERSITY
OF WASHINGTON LIBRARIES, SPECIAL
COLLECTIONS, NOWELL X1324.

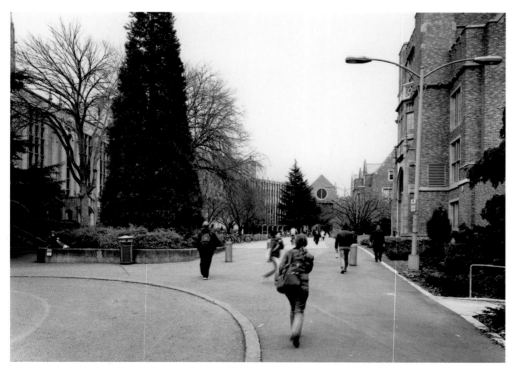

· PLATE 45B ·
Students walking east toward
Allen Library along Grant Lane,
2007. Grant Lane is farther south
than the historic Olympic Place
path but nevertheless serves
the same purpose of channeling
pedestrians to the center
of campus.
PHOTO BY ABBY MARTIN.

· PLATE 46A ·
Looking toward the Court
of Honor and Geyser Basin
from the foot of the Alaska
Monument, 1909.

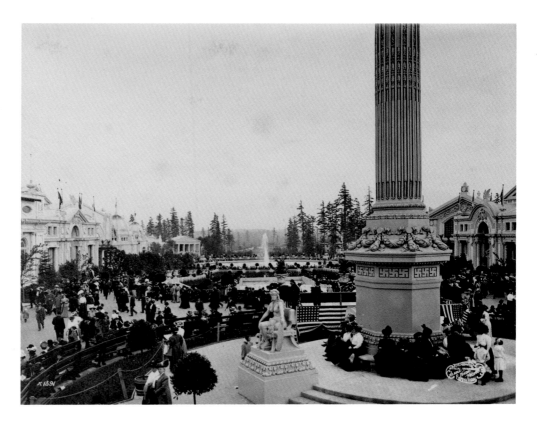

· PLATE 46B ·
Looking south from Red Square
to Rainier Vista, 2008. This
perspective is very close to
that of the original photo.

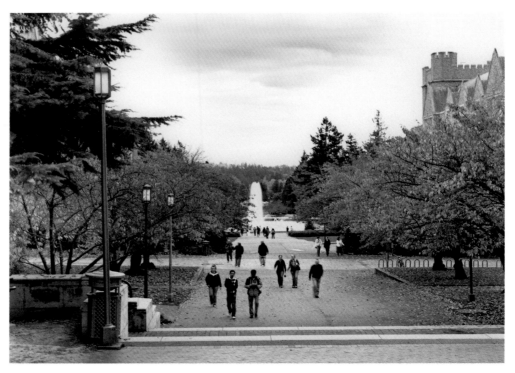

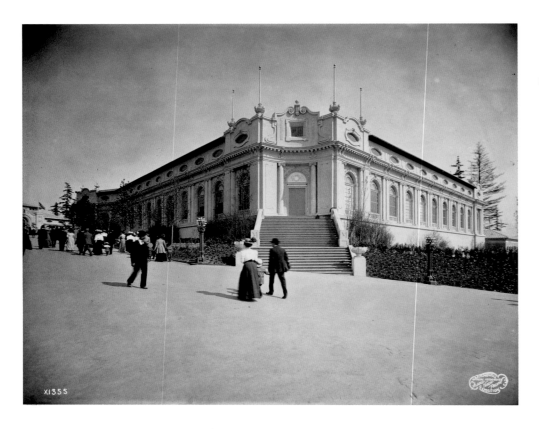

· **PLATE 47A** ·
Northwest corner of the
Alaska Building, 1909.
PHOTO BY FRANK H. NOWELL. UNIVERSITY
OF WASHINGTON LIBRARIES, SPECIAL
COLLECTIONS, NOWELL XI355.

· **PLATE 47B** ·
Grant Place at top of Stevens
Way, 2008. This empty space
at the west end of Stevens Way
was the site of the northwest
corner of the Alaska Building,
but the original camera position
was much farther back.
PHOTO BY LEE ROBERTS.

· **PLATE 48A** ·
Agriculture Building pergolas
during construction, 1908.
PHOTO BY FRANK H. NOWELL. UNIVERSITY
OF WASHINGTON LIBRARIES, SPECIAL
COLLECTIONS, NOWELL X190.

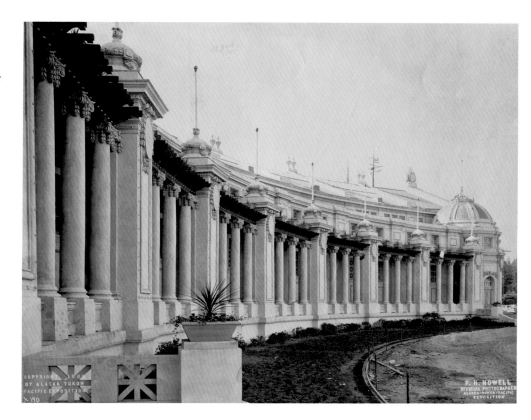

· **PLATE 48B** ·
Looking north from Bagley Hall,
2007. This view from the front
of Bagley Hall is very close to
the historic perspective.
PHOTO BY BEN CARLSON.

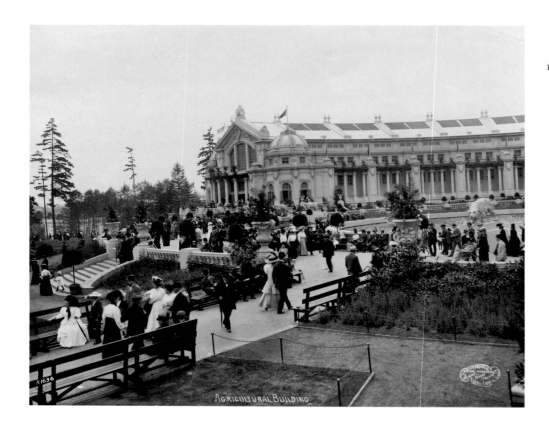

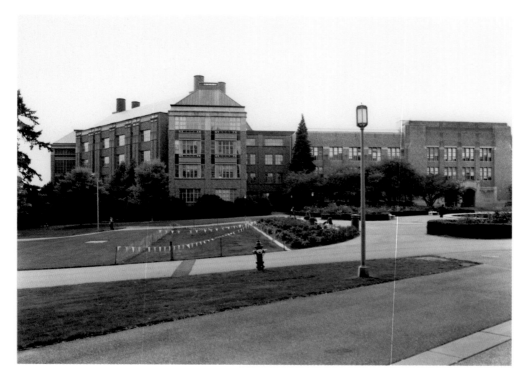

· PLATE 50A ·
Looking west on Yukon Avenue
at the Agriculture Building (left)
and the European Building
(right), 1909.

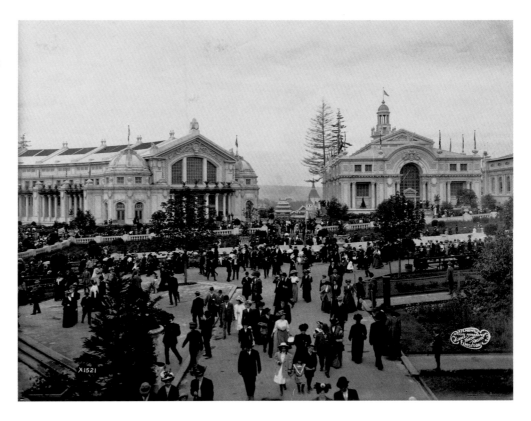

· PLATE 50B ·
Looking west on Thurston
Lane, 2008. This view mimics
the historic view along Yukon
Avenue, which ran parallel about
a hundred feet to the north.

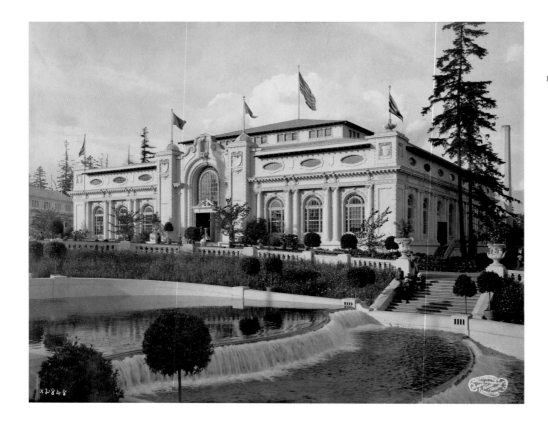

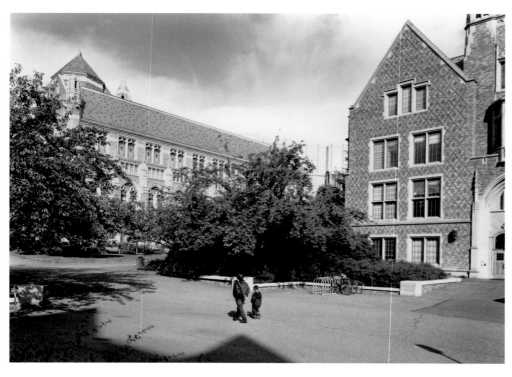

· **PLATE 52A** ·
Court of Honor showing the
Cascades, the Hawaii Building,
and the Oriental Building,
June 1909.

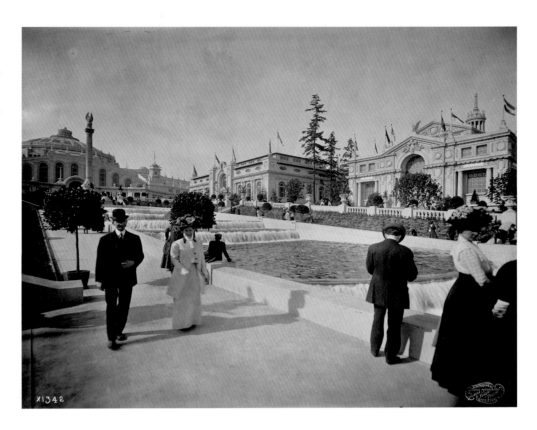

· **PLATE 52B** ·
Looking northeast along Rainier
Vista, 2007. This view includes
Mary Gates Hall on the right and
the tower of Gerberding Hall in
the distant left.

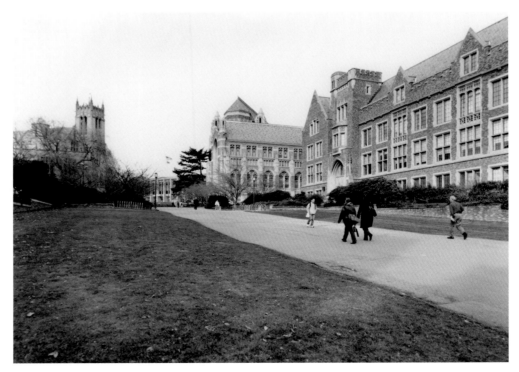

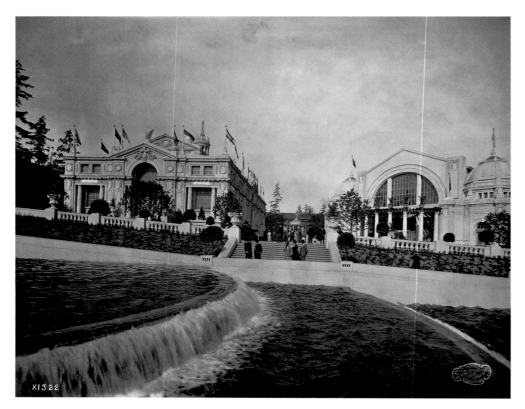

· **PLATE 53A** ·
Looking east across the Cascades
to Yukon Avenue, the Oriental
Building (left), and the
Manufactures Building (right),
June 1909.

Photo by Frank H. Nowell. University
of Washington Libraries, Special
Collections, Nowell XI322.

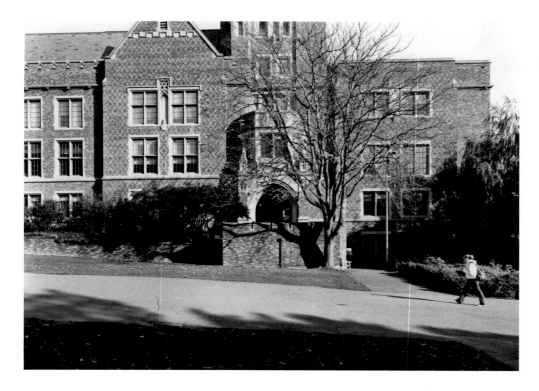

· **PLATE 53B** ·
Mary Gates Hall, 2008. This
perspective is very close to that
of the historic photo, where
Yukon Avenue was aligned
exactly with today's southwest
entrance to Mary Gates Hall.

Photo by John Stamets.

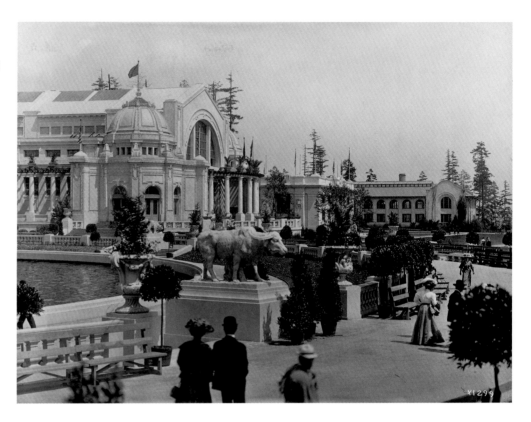

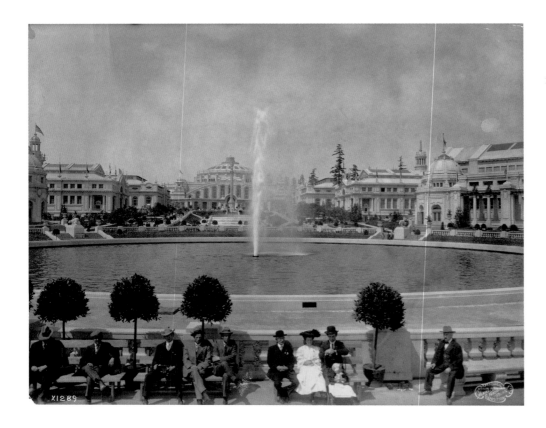

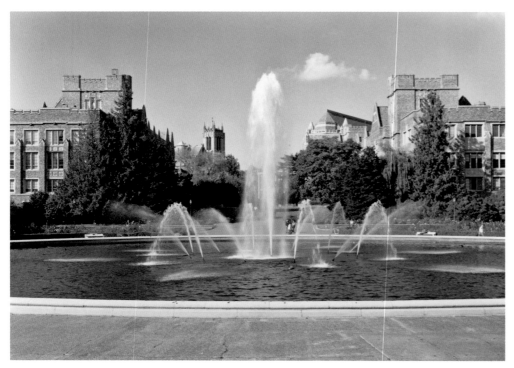

· PLATE 56A ·
View of the Court of Honor
from Geyser Basin illuminated
at night, 1909.
PHOTO BY FRANK H. NOWELL. UNIVERSITY
OF WASHINGTON LIBRARIES, SPECIAL
COLLECTIONS, NOWELL X2246.

· PLATE 56B ·
Looking north from below
Drumheller Fountain at night,
2007.
PHOTO BY JAY FLAMING.

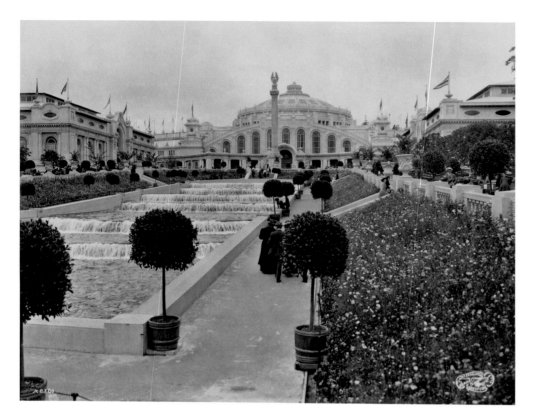

Philippines Building, 1909.

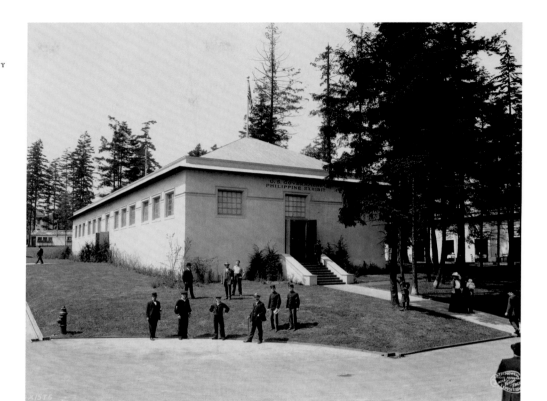

Gowen Hall, 2008. This view of
the southeast corner of Gowen
Hall is about a hundred feet
forward and to the right of the
A-Y-P's Philippines Building, but
otherwise the perspectives
are very similar.

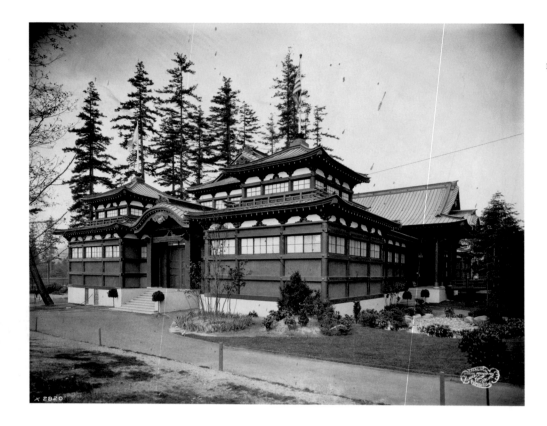

· **PLATE 60A** ·
Music Pavilion and part of
the formal gardens, 1909.
PHOTO BY FRANK H. NOWELL. UNIVERSITY
OF WASHINGTON LIBRARIES, SPECIAL
COLLECTIONS, NOWELL X1546.

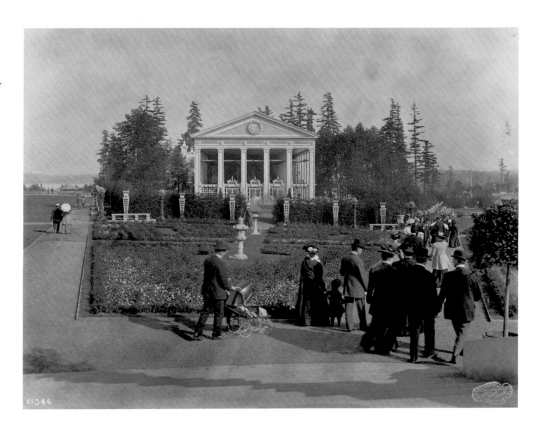

· **PLATE 60B** ·
Lawn in front of Sylvan Grove,
2007. This perspective is very
close to the historic view, with
Rainier Vista on the right and
the Electrical Engineering
Building at the left edge.
PHOTO BY LUKE ANDERSON.

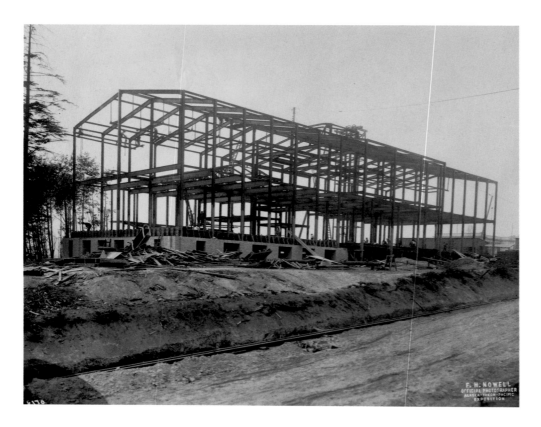

· **PLATE 61A** ·

Construction of the Fine Arts
Building, located at the top of
the Pay Streak, August 27, 1908.
PHOTO BY FRANK H. NOWELL. UNIVERSITY
OF WASHINGTON LIBRARIES, SPECIAL
COLLECTIONS, NOWELL X170.

· **PLATE 61B** ·

Looking northwest to
Architecture Hall, 2008.
This is an almost exact re-
photograph of the historic
construction view.
PHOTO BY JOHN STAMETS.

· PLATE 62A ·
Construction of the Fine Arts
Building nearly completed, 1908.
PHOTO BY FRANK H. NOWELL. UNIVERSITY
OF WASHINGTON LIBRARIES, SPECIAL
COLLECTIONS, NOWELL X416.

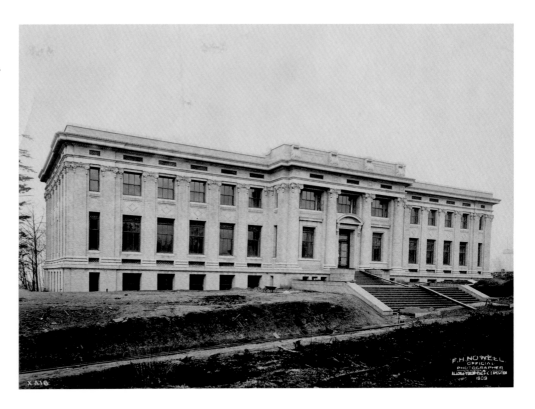

· PLATE 62B ·
Architecture Hall, 2008.
By historic coincidence this
wide-open view of Architecture
Hall was revealed in June 2008
when six ninety-nine-year-old
poplar trees were cut down to
make way for new landscaping.
PHOTO BY JOHN STAMETS.

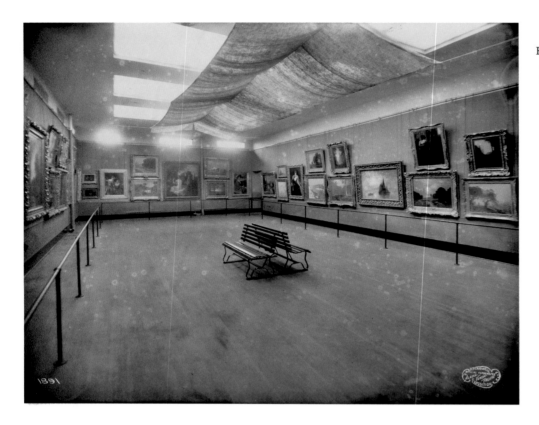

· PLATE 63A ·
Exhibit of paintings in Gallery G
of the Fine Arts Building, 1909.
PHOTO BY FRANK H. NOWELL. UNIVERSITY
OF WASHINGTON LIBRARIES, SPECIAL
COLLECTIONS, NOWELL X1891.

· PLATE 63B ·
Studio, Architecture Hall, 2008.
Today this room on the top floor
of Architecture Hall serves as
a studio for graduate students.
The original ceiling was lower
and at the height of the inverse
ledge at upper right.
PHOTO BY JOHN STAMETS.

· **PLATE 64A** ·
Washington State Women's
Building (across from the Fine
Arts Building), 1909.
PHOTO BY FRANK H. NOWELL. UNIVERSITY
OF WASHINGTON LIBRARIES, SPECIAL
COLLECTIONS, NOWELL X1581.

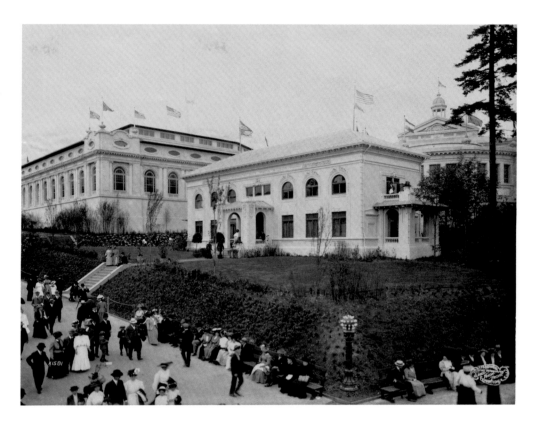

· **PLATE 64B** ·
Cunningham Hall, 2008.
The photographer for the
historic view was perched
higher, but otherwise this
photo of Cunningham Hall
is very similar in perspective.
(Cunningham Hall is scheduled
to be moved in summer of 2009.)
PHOTO BY JOHN STAMETS.

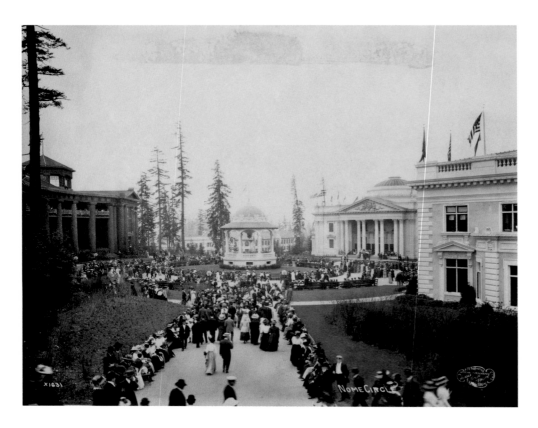

· **PLATE 65B** ·
Looking south across the lawn
between the Husky Union
Building (HUB) and Allen
Library. The camera is aligned
along the same path seen in
the historic view, but it is much
closer to the subject.
PHOTO BY JOHN STAMETS.

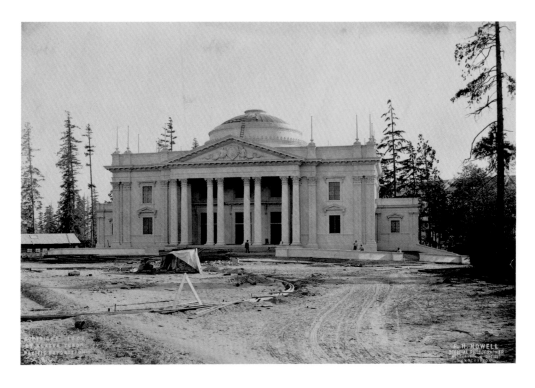

· PLATE 66A ·
Oregon Building under
construction, September 1908.
PHOTO BY FRANK H. NOWELL. UNIVERSITY
OF WASHINGTON LIBRARIES, SPECIAL
COLLECTIONS, NOWELL X1586.

· PLATE 66B ·
Looking south at Sieg Hall
on the right, 2008.
PHOTO BY ABBY MARTIN.

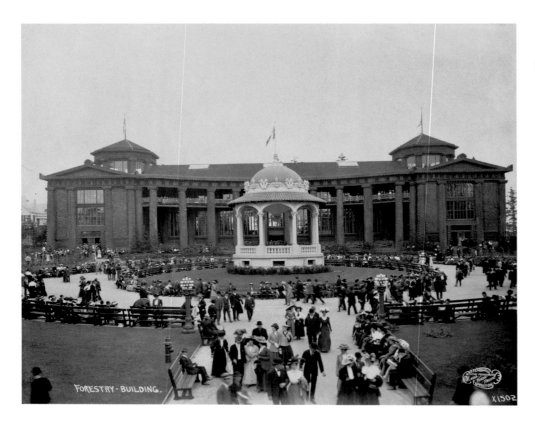

· **PLATE 67B** ·
Husky Union Building, 2008. The footprints of the A-Y-P
Forestry Building and today's HUB overlap, but are aligned
at an approximately forty-five-degree angle. The camera
location for this view of the HUB is close to the camera
location for the historic view.
PHOTO BY ABBY MARTIN.

· **PLATE 67C** ·
Husky Union Building, 2008. This elevation view
of the HUB with the wide expanse of lawn mimics
the look of the historic perspective.
PHOTO BY ABBY MARTIN.

California Building, June 1909.
PHOTO BY FRANK H. NOWELL. UNIVERSITY
OF WASHINGTON LIBRARIES, SPECIAL
COLLECTIONS, NOWELL X1707.

Path between Allen Library
and the Husky Union Building,
2008. This view looking north
across the HUB lawn shows
the approximate location of
the A-Y-P California Building.
PHOTO BY VALERIE VARGAS.

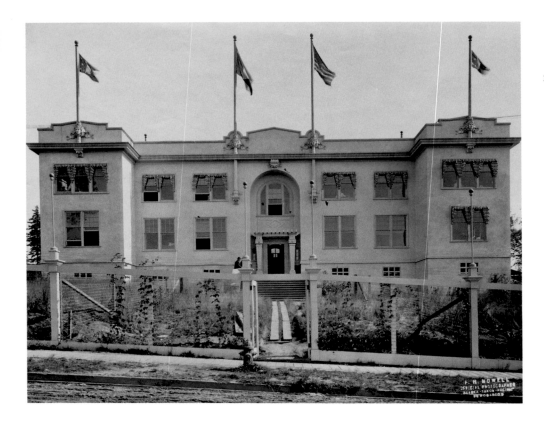

· **PLATE 69A** ·
Administration Building
under construction, 1908.
PHOTO BY FRANK H. NOWELL. UNIVERSITY
OF WASHINGTON LIBRARIES, SPECIAL
COLLECTIONS, AYP1035.

· **PLATE 69B** ·
Henry Art Gallery, 2008.
The camera position for
this view looking east across
15th Avenue NE is probably
at the same position as
Frank Nowell's camera
for the 1908 view.
PHOTO BY CARLENE THATCHER-MARTIN.

· **PLATE 70A** ·
Emergency Hospital and
horse-drawn ambulance, 1909.
The hospital was one of the first
buildings to be constructed for
the exposition.
<small>PHOTO BY FRANK H. NOWELL. UNIVERSITY
OF WASHINGTON LIBRARIES, SPECIAL
COLLECTIONS, NOWELL X2365.</small>

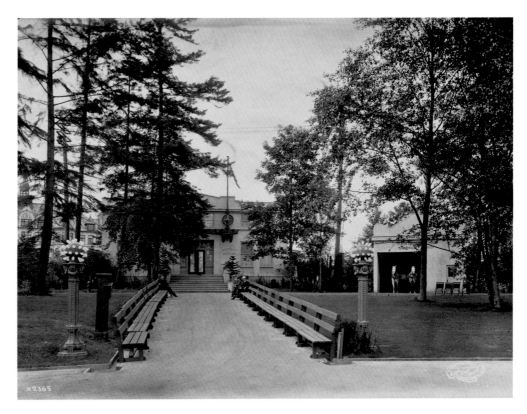

· **PLATE 70B** ·
Raitt Hall, 2007. This view,
looking west across the Quad
to Raitt Hall, represents
the northern edge of the
A-Y-P grounds.
<small>PHOTO BY JAY FLAMING.</small>

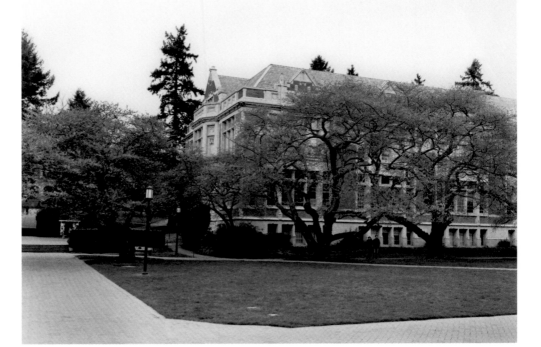

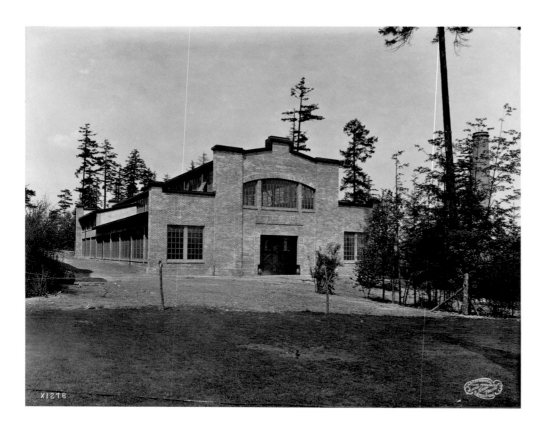

· PLATE 71A ·
Foundry, 1909.
PHOTO BY FRANK H. NOWELL. UNIVERSITY
OF WASHINGTON LIBRARIES, SPECIAL
COLLECTIONS, NOWELL X1278.

· PLATE 71B ·
Engineering Annex, 2007.
The original Foundry is
now embedded within
the Engineering Annex.
PHOTO BY JAY FLAMING.

· PLATE 72A ·
South grounds of the exposition showing the Lake Washington entrance gate and boat landing, 1909.
PHOTO BY FRANK H. NOWELL. UNIVERSITY OF WASHINGTON LIBRARIES, SPECIAL COLLECTIONS, NOWELL X2708.

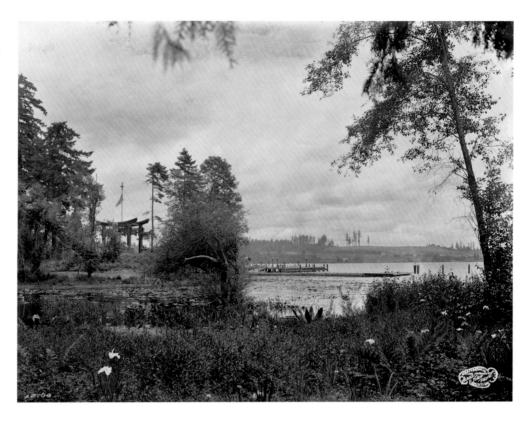

· PLATE 72B ·
Lake Washington waterfront, with Laurelhurst in the distance, 2008. This view is taken about two hundred yards from the historic photo, but otherwise it seems that not much has changed.
PHOTO BY SUSIE PHILIPSEN.

SELECT BIBLIOGRAPHY

Many of the primary sources for this book can be found in the University of Washington Libraries Special Collections archive, which contains an extensive collection of materials pertaining to the Alaska-Yukon-Pacific Exposition, including books, pamphlets, photographs, and ephemera from the time of the fair along with about forty scrapbooks of clippings from local and out-of-town newspapers. Special Collections also has extensive holdings on all aspects of the Klondike Gold Rush.

Many sources are available online. The following websites were of particular value:

Chinese in Northwest America Research Committee on the Alaska-Yukon-Pacific Exposition, http://www.cinarc.org/AYPE

Guide to the Frank H. Nowell Alaska-Yukon-Pacific Exposition Photographs, http://www.lib.washington.edu/specialcoll/findaids/docs/photosgraphics/AlaskaYukonPacificExpositionPHColl727.xml

HistoryLink (an online encyclopedia of Washington state history), http://www.historylink.org

Juneau-Douglas City Museum, Digital Bob (stories from local Juneau newspapers from the 1880s and 1890s, compiled by Robert DeArmond), http://www.juneau.org/parkrec/museum/forms/digitalbob

Abbott, Carl. *The Great Extravaganza: Portland and the Lewis and Clark Exposition.* 1981. 3d ed., Portland: Oregon Historical Society, 2004.

Alaska Club. *Album 1904.* Seattle: Covington-McDonald, 1904.

Alaska-Yukon-Pacific Exposition. *Catalogues and Lists.* Seattle, 1909.

——. *The Exposition Beautiful.* Seattle, 1909.

——. *Alaska-Yukon-Pacific Exposition General History.* Seattle, 1909.

——. *Official Daily Program.* Seattle, 1909.

——. *Official Ground Plan of the Alaska-Yukon-Pacific Exposition.* Seattle, 1909.

——. *Secretary's Report of the Alaska-Yukon-Pacific Exposition Held at Seattle June 1 to October 16, 1909.* Seattle: Gateway Printing Co., 1911.

The Alaska-Yukon-Pacific Exposition Illustrated. Seattle: Robert A. Reid, 1909.

"Alaska-Yukon-Pacific Exposition (1909): Pay Streak Amusements." HistoryLink. http://www.historylink.org/index.cfm?DisplayPage=output.cfm&file_id=8635

"Alaska-Yukon-Pacific Exposition, 1909: A Slide Show of Seattle's First World's Fair." History Link. http://www.historylink.org/index.cfm?DisplayPage=output.cfm&file_id=7082

"The Alaska-Yukon-Pacific Exposition of 1909: Photographs by Frank H. Nowell." *Alaska Journal* 14, no. 3 (Summer 1984): 8–14.

Andrews, Mildred. "Woman Suffrage (19th Amendment to the Constitution of the United States) Becomes Law on August 26, 1920." HistoryLink. http://www.historylink.org/index.cfm?DisplayPage=output.cfm&file_id=5214

Andrews, Ralph. *Photographers of the Frontier West: Their Lives and Works, 1875 to 1915.* Seattle: Superior [1965].

Bagley, Clarence B. *History of Seattle from the Earliest Settlement to the Present Time.* 3 vols. Chicago: S. J. Clarke, 1916.

Becker, Paula. "Alaska-Yukon-Pacific Exposition (1909): Woman Suffrage." HistoryLink. http://www.historylink.org/index.cfm?DisplayPage=output.cfm&file_id=8587

Blair, Karen. "The Limits of Sisterhood: The Women's Building in Seattle, 1908–1921." *Frontiers* 8, no. 1 (1984): 45–52.

Brown, Julie K. *Contesting Images: Photography and the World's Columbian Exposition.* Tucson: University of Arizona Press, 1994.

"The Butler Brothers Gold Rush: The Nome Album 1900–1901." University of Alaska Fairbanks. http://photolab.elmer.uaf.edu/gallery/photos/19640033/butler/index.html

Clark, Horace F. *Miner's Manual, United States, Alaska, the Klondike.* Chicago: Callahan & Co., 1898.

Cole, Terrence. *Nome, City of the Golden Beaches.* Anchorage: Alaska Geographic Society 11, no. 1, 1984.

——. "Ocean to Ocean by Model T: Henry Ford and the 1909 Transcontinental Auto Contest." *Journal of Sport History* 18, no. 2 (Summer 1991): 224–40.

——. "Promoting the Pacific Rim: The Alaska-Yukon-Pacific Exposition of 1909." *Alaska History* 6, no. 1 (Spring 1991): 18–34.

Danielson, Cathy, comp. "Alaska Free Press Newspaper Indexing Project." Alaska State Library. http://www.library.state.ak.us/hist/hist_docs/indexes/Index_to%20_Alaska_Free_Press.pdf

DeArmond, R. N. *The Founding of Juneau.* Juneau, AK: Gastineau Channel Centennial Association, 1980.

Deschner, Donald. "Frank H. Nowell." *Alaska Review,* Fall–Winter 1968–69, 193–97.

Droker, Howard. "On the Pay Streak at the Alaska-Yukon-Pacific Exposition." *Portage* 2, no 3 (Summer 1981): 4–9.

Duncan, Don. *Meet Me at the Center: The Story of Seattle Center from the Beginnings to the 1962 Seattle World's Fair to the Twenty-first Century.* Seattle: Seattle Center Foundation, 1992.

Ford, G. M. *A Blind Eye,* New York: William Morrow, 2003.

Ford Motor Company. *The Story of the Race.* 1959? (Reprint of *The Story of the Race: How the Ford Car Won the Transcontinental Contest for the Guggenheim Trophy, Told by One of the Crew on Ford Car No. 1.* 1909?)

Frykman, George. "The Alaska-Yukon-Pacific Exposition, 1909." *Pacific Northwest Quarterly* 53, no. 3 (July 1962): 89–99.

Gidley, Mick. *Edward Curtis and the North American Indian Incorporated.* New York: Cambridge University Press, 1998.

Griffin, Tom. "Centennial: How Fate, Visionaries and Some Shameless Boosters Transformed Logged-Over Land into the 'Most Beautiful' Campus in the Nation." *Columns Magazine,* University of Washington. http://www.washington.edu/alumni/columns/sept95/centennial.html

Harris, Neil, Wim de Wit, James Gilbert, and Robert W. Rydell. *Grand Illusions: Chicago's World's Fair of 1893.* Chicago: Chicago Historical Society, 1993.

Harrison, Edward. *Nome and the Seward Peninsula: History, Description, Biographies and Stories.* Seattle: Harrison, 1905.

Higginson, Ella. *Alaska, the Great Country.* New York: Macmillan, 1923.

Ho, Chuimei, and Bennet Bronson. "The Dragon at the A-Y-P." Paper presented at the meeting of the Pacific Northwest Historians Guild, Seattle, March 6–7, 2009.

Jackson, Sheldon. *Education and Reindeer in Alaska, 1903.* Washington, DC: Government Printing Office, 1904.

Johnston, Norman. "The Olmsted Brothers and the Alaska-Yukon-Pacific Exposition: 'Eternal Loveliness.'" *Pacific Northwest Quarterly* 75, no. 2 (1984): 50–61.

Jones, Preston. *Empire's Edge: American Society in Nome, Alaska, 1898–1934.* Fairbanks: University of Alaska Press, 2007.

Juneau-Douglas City Museum, Digital Bob, NGC_bob_1980-06-16_589, July 31, 1890. http://www.juneau.org/parkrec/museum/forms/digitalbob/readarticle.php?UID=589&newxtkey=nowell

Kerlew, Dan. "Alaska-Yukon-Pacific Exposition 1909: Seattle, Washington, Images of the Fair." AYPE.com, http://aype.com/

Kiffer, David. "Cruising to Alaska, circa 1887." SitNews Stories in the News. http://www.sitnews.us/Kiffer/CruisingAK/080707_alaska.html

Kumor, Georgia Ann. "Doing Good Work for the University of Washington: The Alaska-Yukon-Pacific Exposition, 1906–1909." *Portage* 7, no. 1–2 (1986): 14–21.

Lange, Greg. "Alaska-Yukon-Pacific Exposition Opens for a 138-day Run on June 1, 1909." HistoryLink. http://www.historylink.org/index.cfm?DisplayPage=output.cfm&file_id=5371

———. "U.S. President William Howard Taft Attends the Alaska-Yukon-Pacific Exposition on September 29, 1909." HistoryLink. http://www.historylink.org/index.cfm?DisplayPage=output.cfm&file_id=880

———, and Alan J. Stein. "A-Y-P Groundbreaking Ceremonies Take Place on June 1, 1909." HistoryLink. http://www.historylink.org/index.cfm?DisplayPage=output.cfm&file_id=692

Lauzen, Elizabeth. "Marketing the Image of the Last Frontier." *Alaska Journal* 12, no. 2 (Spring 1982): 13–19.

Lee, Shelley S. "The Contradictions of Cosmopolitanism: Consuming the Orient at the Alaska-Yukon Pacific Exposition and the International Potlatch Festival, 1909–1934." *Western Historical Quarterly* 38, no. 3 (Autumn 2007). Also available online at http://www.historycooperative.org/journals/whq/38.3/lee.html

Levi, Steven C. *Boom and Bust in the Alaska Goldfields: A Multicultural Adventure.* Westport, CT: Praeger, 2008.

Lieberman, Hannah. "Incubator Baby Shows: A Medical and Social Frontier." *The History Teacher,* 35, no. 1 (November 2001): 81–88.

Meany, Edmond S. "What It All Means: The Great West, Its History, and the Yukon Exposition." History and Literature of the Pacific Northwest. http://www.washington.edu/uwired/outreach/cspn/Website/Hist%20n%20Lit/Part%20Four/Texts/Meany%20Means.html

"A Memorable Enterprise: The AYPE and the City of Seattle." Seattle Municipal Archives. http://www.seattle.gov/CityArchives/Exhibits/AYPE/default.htm

Merlino, Kathryn Rogers. "Classicizing the Wilderness: The Forestry Building at the A-Y-P." Paper presented at the meeting of the Pacific Northwest Historians Guild, Seattle, March 6–7, 2009.

Merrick, Frank. "Exposition Publicity." *Alaska-Yukon Magazine* 5, no. 6 (September 1908): 449–52.

———. "Ground Breaking Ceremonies of Alaska-Yukon-Pacific Exposition." *Alaska-Yukon Magazine* 3, no. 5 (July 1907): 415–21.

Mighetto, Lisa, and Marcia Babcock Montgomery. *Hard Drive to the Klondike: Promoting Seattle during the Gold Rush.* http://www.nps.gov/archive/klse/hrs/hrs.htm Also available in print version; Seattle: Northwest Interpretive Center in association with University of Washington Press, 2002.

Minter, Roy. *The White Pass: Gateway to the Klondike.* Toronto: McClelland and Stewart, 1987.

Monroe, Robert. "Up in the Air: On Balloons and Photography in Washington in 1909." *Northwest Photography,* June 1982, 4–5.

Morse, Kathryn. "The Klondike Gold Rush." Center for the Study of the Pacific Northwest. http://www.washington.edu/uwired/outreach/cspn/Website/Resources/Curriculum/Klondike/Klondike%20Main.html

National Park Service. "Arctic Building." http://www.nps.gov/nr/travel/seattle/s22.htm

New York (State). Legislature. Committee to Alaska-Yukon Pacific-Exposition. *Report of the Legislative Committee from the State of New York to the Alaska-Yukon-Pacific Exposition, 1909. Transmitted to the Legislature January 25, 1910.* Albany: J.B. Lyon, 1910.

"1905 Lewis & Clark Exposition." http://www.history.pdx.edu/guildslake/topics/mainfair.htm

Norris, Frank R. "The Chilkoot Trail Tramways." Edited by Karl Burcke. In *Study Tour of the Yukon and Alaska.* Ottawa: Society for Industrial Archeology, 1990.

Northam, Janet A., and Jack W. Berryman. "Sport and Urban Boosterism in the Pacific Northwest: Seattle's Alaska-Yukon-Pacific Exposition, 1909." *Journal of the West* 17, no. 3 (July 1978): 53–60.

Nowell, Frank H. "Narrative." Unpublished paper, possibly for the Sons of the Pioneers, no date. In the possession of the author.

Nowell, Willis. Unpublished paper, no date. Nowell Family Papers, 1883–1950. Alaska State Library, Alaska Historical Collections.

"Nowell Collection of Early Alaska Photographs 1898–1910 Owned by Webster & Stevens." Unpublished paper, no date. Photographer's Reference File—Nowell, Frank. University of Washington Libraries, Special Collections.

Ochsner, Jeffrey Karl, ed. *Shaping Seattle Architecture: A Historical Guide to the Architects.* Seattle: University of Washington Press in association with the American Institute of Architects Seattle Chapter and the Seattle Architectural Foundation, 1998.

O'Gorman, James F. "The Hoo Hoo House, Alaska-Yukon-Pacific Exposition." *Journal of the Society of Architectural Historians* 19, no. 3 (October 1960): 123–25.

Raymond, W. H. "Uncle Sam's Next Big Show." *Sunset Magazine,* May 1909.

Rickerson, Carla, "Alaska-Yukon-Pacific." Paper presented at Saturday Seminar, Seattle, November 3, 2001.

Rose, Julie K. "A History of the Fair." The World's Columbian Exposition: Idea, Experience, Aftermath. http://xroads.virginia.edu/~MA96/ WCE/history.html

Rupp, James M. "1909 Seattle and the Alaska-Yukon-Pacific Exposition." Paper presented at the Monday Club, Seattle, June 1, 1998.

Rydell, Robert W. *All the World's a Fair: Visions of Empire at American International Expositions, 1876–1916.* Chicago: University of Chicago Press, 1984.

"Seattle Post-Intelligencer Tallies Total Cost for Seeing Every Paid Attraction at A-Y-P Exposition on June 18, 1909." HistoryLink. http://www .historylink.org/index.cfm?DisplayPage=output.cfm&file_id=8667

Smithsonian Museum. *Report of the United States National Museum.* Washington, DC: U.S. Government Printing Office, 1889.

"Souvenir, Exposition July 17, 1909." *Alaska-Yukon-Pacific Weekly News.* Seattle, 1909.

Stein, Alan J. "Century 21: The 1962 Seattle World's Fair Part 1." History-Link. http://www.historylink.org/index.cfm?DisplayPage=output .cfm&file_id=2290

———. "Seattle Celebrates Silver Anniversary of Klondike Gold Rush on July 17, 1922." HistoryLink. http://www.historylink.org/index .cfm?DisplayPage=output.cfm&file_id=4311

———. "Smith Day Is Celebrated at the AYPE on September 2, 1909." HistoryLink. http://www.historylink.org/index. cfm?DisplayPage=output.cfm&file_id=8198

———, and Paula Becker. "Alaska-Yukon-Pacific Exposition (1909): A Cybertour of Selected Buildings." HistoryLink. http://www .historylink.org/index.cfm?DisplayPage=output.cfm&file_id=8678

Stone, David and Brenda. *Hard Rock Gold: The Story of the Great Mines That Were the Heartbeat of Juneau.* Juneau, AK: Juneau Centennial Committee, 1980.

"The Story of a Whale Hunt." *Alaska Journal* 11, no. 1 (1981): 134–43.

Trachtenberg, Alan. "The Incorporation of America: Culture and Society in the Gilded Age." http://xroads.virginia.edu.

U.S. Government Board of Managers, Alaska-Yukon-Pacific Exposition. *Participation in the Alaska-Yukon-Pacific Exposition.* Washington, DC: Government Printing Office, 1911.

Wilson, T. G. "The Eskimos' First Christmas Tree." Alaska's Gold. http:// www.library.state.ak.us/goldrush/ARCHIVES/manu1/004_8.htm

Woodside, Henry J. "Dawson As It Is." *The Canadian Magazine of Politics, Science, Art and Literature* 18 (May–October 1901): 411.

NEWSPAPERS

Alaska Free Press
Alaska Weekly (Seattle)
Alaska-Yukon-Pacific Weekly News
Daily Alaska Dispatch
Fairbanks Daily Times
Fairbanks Sunday Times
Juneau City Mining Record
Nome Daily Gold Digger
Nome News
Seattle Daily Times
Seattle Post-Intelligencer
Seattle Star
Seattle Sun
Seattle Times
Teller News

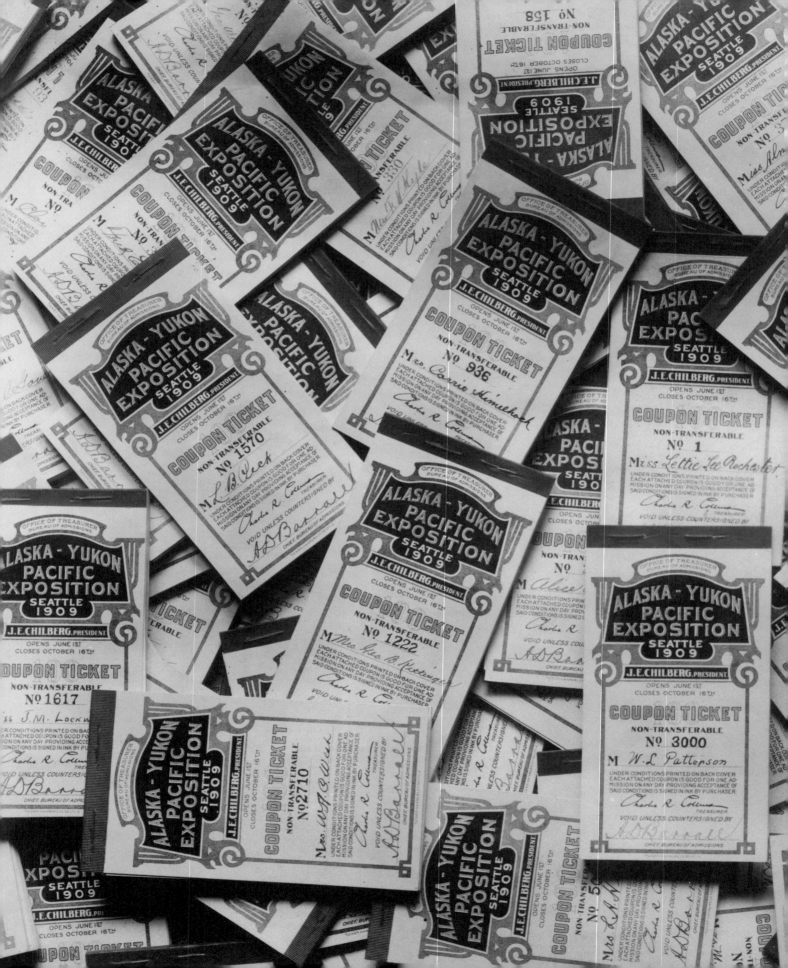